IMAGES
of America
TYLER

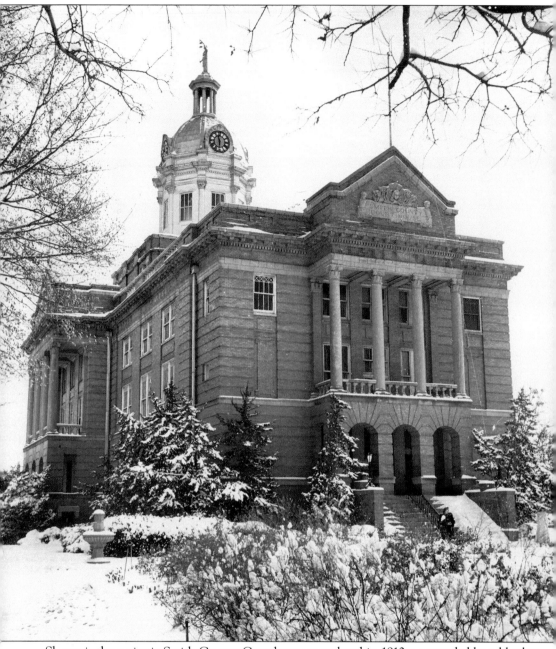

Shown is the majestic Smith County Courthouse completed in 1910, surrounded by a blanket of snow—a rare occurrence in Tyler. This courthouse was demolished in 1955, a loss still felt in the hearts of locals. (Courtesy of the Smith County Historical Society.)

ON THE COVER: Rose Queen Carolyn Riviere rides through downtown atop her parade float during the Texas Rose Festival of 1947. (Courtesy of the Smith County Historical Society.)

IMAGES
of America
TYLER

Robert E. Reed Jr.

Copyright © 2008 by Robert E. Reed Jr.
ISBN 978-0-7385-4841-8

Published by Arcadia Publishing
Charleston, South Carolina

Printed in the United States of America

Library of Congress Catalog Card Number: 2007935839

For all general information contact Arcadia Publishing at:
Telephone 843-853-2070
Fax 843-853-0044
E-mail sales@arcadiapublishing.com
For customer service and orders:
Toll-Free 1-888-313-2665

Visit us on the Internet at www.arcadiapublishing.com

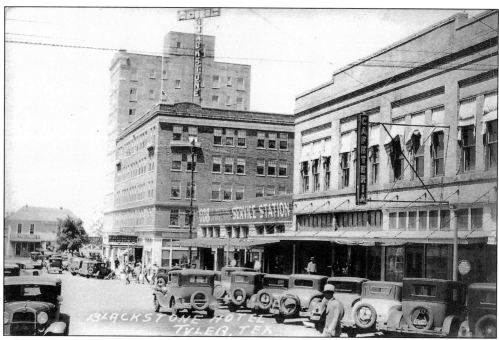

This postcard view is looking up North Broadway Avenue around the mid-1930s. With the discovery of the East Texas Oilfield, hotels and boardinghouses were full. At the Blackstone Hotel, the lobby furniture was removed to make room for cots. The Great Depression was here, but oil helped soften the blow for Tyler. (Author's collection.)

CONTENTS

Acknowledgments		6
Introduction		7
1.	1850s through 1870s	9
2.	1880s through 1900s	21
3.	1910s through 1930s	49
4.	1940s through 1960s	95

ACKNOWLEDGMENTS

The majority of the images used in the book are from the archives of the Smith County Historical Society. Additional images were used courtesy of the following organizations and individuals: Bonner-Whitaker-McClendon House, Brookshire's Grocery Company, Caldwell Zoo, Camp Fannin Association, Library of Congress, Trinity Lutheran Church, Tyler Civic Theatre Center, Tyler Police Department, Tyler Public Library, Tyler Tap Chapter of the Cotton Belt Rail Historical Society, Gail Clark, Marie Dusek, Randy E. Pruett/Miss Texas Organization, Tommy Tomlin, and Fannie Mae Wohletz. Images from the author's personal collection were also included.

The most utilized sources of information were issues of *Chronicles of the Smith County, Texas* and James Smallwood's two-volume *The History of the Smith County, Texas: Born in Dixie*, all of which are publications of the Smith County Historical Society.

Special thanks go to the following:

- The members of the Smith County Historical Society, in particular Vicki Betts, Mary Jane McNamara, and Gretchen Leath, for encouragement and assistance.
- Henry Bell of the Tyler Chamber of Commerce and Justine Turner of the Tyler Convention and Visitors Bureau, for support of the project.
- The staff of Arcadia Publishing, in particular Christine Talbot, publishing manager of the West, and Kristie Kelly, editor, for encouragement and guidance.
- My family, in particular my wife, Kay; my mother, Virginia; my sister, Chris; and her husband, Pete, for encouragement and assistance.
- To my young son, Evan, for patience. Daddy is finally done. We can play now!

I would like to dedicate this book to my dad, Robert E. Reed Sr. Born in St. Louis, Missouri, he moved his family to Tyler when his job was transferred there by the Cotton Belt Railroad. He was proud of his adopted city and state, and he enjoyed the rest of his life there.

To learn more about the history of Tyler and Smith County, contact:

Smith County Historical Society
125 South College Avenue
Tyler, Texas 75702
903-592-5993

For Tyler tourist information, contact:

Tyler Chamber of Commerce
315 North Broadway Avenue
Tyler, Texas 75702
800-235-5712

INTRODUCTION

The intention of this book is to present a photographic history of Tyler, Texas, from its very beginning through the decade of the 1960s. There are several inherent problems in doing so. Obviously, space limitations will require some worthy subjects, whether person, place, or event, to be left out. This book will give an overview of it all; some things important, and perhaps some things trivial. But either way, both make up a part of the history. Additionally, when attempting to give a precise address for places, there are the usual problems of streets being renamed and addresses renumbered. To give today's reader the best idea of a specific location, modern-day street names and numbers will be used or often a general street intersection description. Finally, the very fact that this is a photographic history causes a problem. Cameras were not always around, especially in the earliest days. To be able to inform the reader of some of that earliest history, the remainder of this introduction will give a brief overview of the days before the photographers arrived. While the area has a worthy pre-Tyler history to reveal, including Native Americans, early European visitors, as well as its days as part of the Republic of Texas, this story will begin with Tyler's birth.

On February 28, 1845, the U.S. Congress passed, and Pres. John Tyler later signed, a joint resolution to annex Texas, if Texas agreed. In October 1845, Texas voters did so, and Texas was admitted as a state on December 29, 1845.

Soon after Texas joined its northern neighbor, the new Texas State Legislature met and, among other business, created several new counties. One of those was Smith County, carved out of the large Nacogdoches County from the days of the Republic of Texas. The county was named after Gen. James Smith, who came to Texas in 1816, fought in the Texas Revolution, and served in the Indian Wars. The legislature also decided to call the county seat Tyler, naming it after U.S. president John Tyler to honor him for supporting the annexation of Texas. The date was April 11, 1846.

Five residents of the new Smith County were appointed commissioners by the legislature: John Dewberry, William B. Duncan, James C. Hill, John Lollar, and Elisha E. Lott. They set about determining where to locate Tyler. The Texas State Legislature required county seats be located within three miles of the geographical center of the new counties, so the commissioners proceeded to locate that center. It is said that the actual center of Smith County is east of present-day Tyler, but because of the terrain, they chose a better location. The spot was indeed good: high ground with many nearby springs to provide water.

Thomas Jefferson Hays surveyed 100 acres in 1846, dividing it into blocks and further into lots. A large double block in the center was set aside for the public square. Edgar Pollett deeded the 100 acres to the commissioners for $150 on February 6, 1847. The commissioners proceeded to sell the lots through auctions, the first of which was held on October 12, 1846. These auctions continued through April 1852. Originally, the lots facing the square ranged from $15 to $30. By 1850, they increased in value ranging from $50 to $100.

On August 8, 1846, the first Smith County elections were held, with the following results: Samuel W. Farmer (county judge), A. W. Martin (county clerk), C. C. Alexander (district clerk),

W. B. Thompson (tax assessor and collector), and Craig Wren (treasurer). In November, the county court set up in an abandoned one-room log cabin, which stood near the present-day 700-block of West Erwin Street. Hence, this was the first county courthouse.

John Lollar, one of the original commissioners appointed by the legislature, built the first house in Tyler. This log cabin was just outside the city limits, approximately two or three current blocks north of the city center. Tyler's first post office was established on March 8, 1847, and the first postmaster was Elisha E. Lott, another of the original commissioners appointed by the legislature. The Baptist church organized on April 8, 1848, about the same year the Methodists did. Local Masons organized St. John's Lodge No. 53 in December 1848 and were chartered by the end of the following month.

The county's first jail was built in 1847 about one block east of the square, near present-day East Ferguson Street. That same year, the second county courthouse was occupied: another one-room log cabin, which stood around the present-day 100-block of West Ferguson Street. In late 1847, construction was completed on the third courthouse, an approximately 26-foot-long by 20-foot-wide log cabin built by Christopher Columbus Alexander for $200. It was occupied in January 1848. It soon would be deemed too small, and on August 21 of the same year, the commissioners court would approve its sale at public auction.

The Texas State Legislature incorporated Tyler on January 29, 1850. The following men were elected the first officers on June 22, 1850: William Stringfellow (mayor), Francis M. Bell (alderman), John Breese (alderman), John C. Bulger (alderman), William S. Caldwell (alderman), F. Jordan Ham (alderman), Stephen Reaves (alderman), Rufus B. Sigler (alderman), James C. Rogers (constable), and Daniel J. McLemore (collector). Also in 1850, a branch of the Texas Supreme Court was located in Tyler. The first session convened on April 7, 1851, and it continued one session a year until 1892.

Also in 1851, a federal court was placed in Tyler by Congress, one of three in the district of Texas. The population within a one-mile radius of the courthouse was 276. On May 24, 1851, the Smith County Commissioners Court ordered a brick courthouse built in the center of the public square. Littleton Yarbrough was awarded the $9,000 contract on July 7, and the cornerstone was laid on December 13.

From this point, the history will be shared as seen through the lens of a camera.

One
1850s THROUGH 1870s

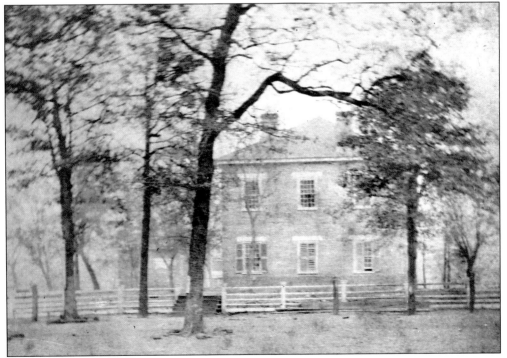

After a series of three log cabins served as the Smith County Courthouse, construction was started on a new courthouse in the center of the square in 1851. It was the first brick structure in Tyler. To supply his construction project, Littleton Yarbrough established the city's first brick plant and yard, which was located just east of Oakwood Cemetery. (Courtesy of the Smith County Historical Society.)

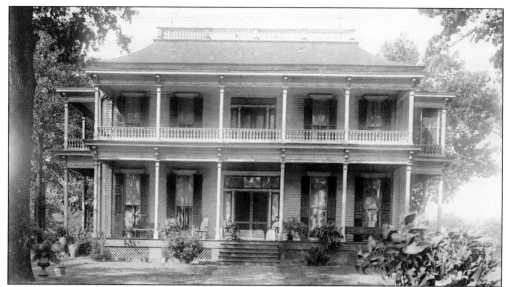

The Goodman-LeGrand house, located at 624 North Broadway Avenue, was built in 1859 as a one-story house by Samuel Gallatin Smith, who called it "Bonnie Castle." It was sold to Franklin Newman Gary in 1861, then to Dr. Samuel Adams Goodman Sr. in 1866. It remained in the Goodman family for more than 70 years. Sallie Goodman LeGrand, the third generation of the Goodman family to live in the house, bequeathed the Goodman-LeGrand house and grounds to the City of Tyler upon her death in 1939. The above view includes the second story that was added around 1880, while the one below shows the dining room decorated for a wedding. The house, now the Goodman Museum, was the first Tyler property to be listed on the National Register of Historic Places. (Both courtesy of the Smith County Historical Society.)

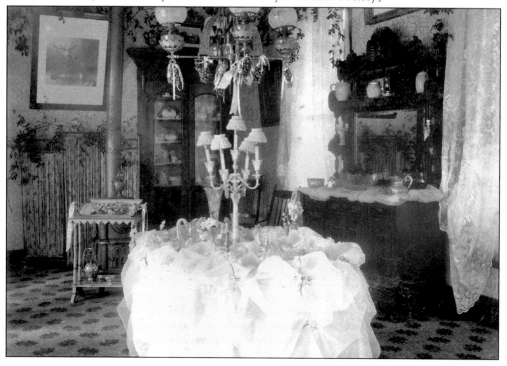

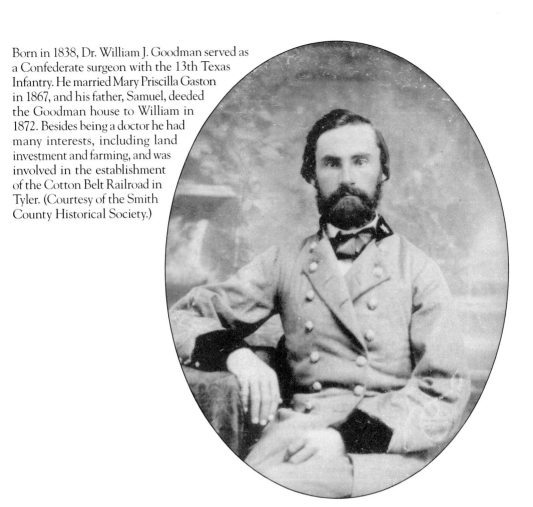

Born in 1838, Dr. William J. Goodman served as a Confederate surgeon with the 13th Texas Infantry. He married Mary Priscilla Gaston in 1867, and his father, Samuel, deeded the Goodman house to William in 1872. Besides being a doctor he had many interests, including land investment and farming, and was involved in the establishment of the Cotton Belt Railroad in Tyler. (Courtesy of the Smith County Historical Society.)

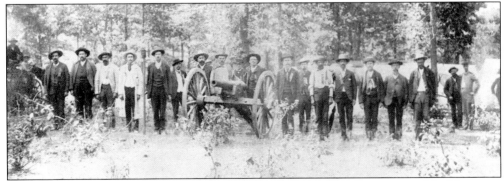

Formed in 1861, the Douglas Battery was the only Texas artillery unit to serve east of the Mississippi River and reportedly was the first Confederate unit to volunteer "for the duration of the war." When the original commanding officer John J. Good was reappointed, James P. Douglas from Tyler was promoted to captain and commander. Shown is a reunion in Tyler in August 1886. (Courtesy of the Smith County Historical Society.)

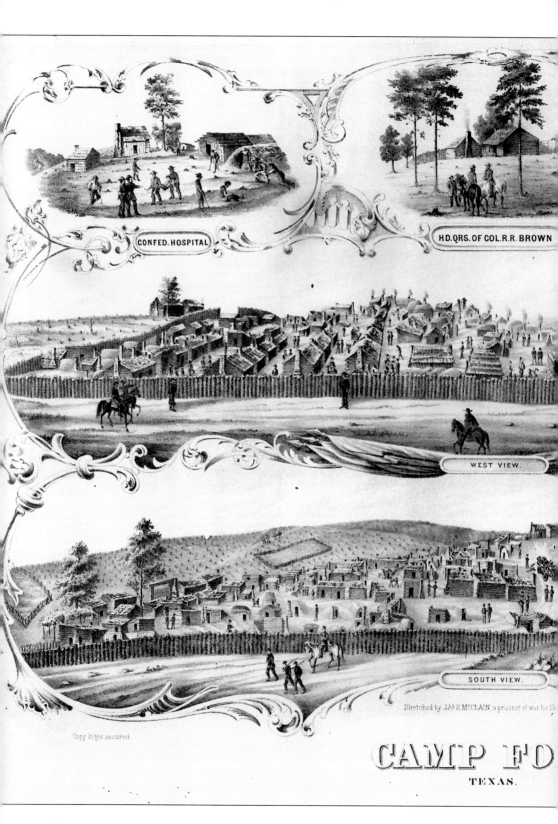

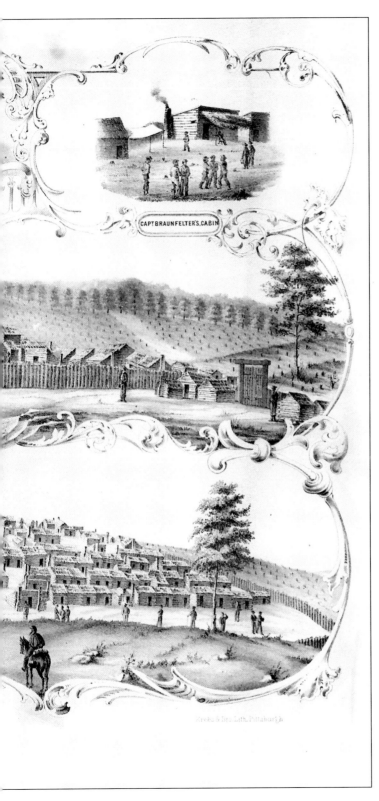

Camp Ford, four miles northeast of Tyler, was originally a Confederate training facility. In 1863, it became a prisoner camp, eventually the largest Confederate prisoner-of-war camp west of the Mississippi River. An estimated 5,470 prisoners passed through the camp. The mortality rate was around 5.6 percent, making the camp one of the least deadly of all North and South prison camps combined. While escape attempts were frequent, the guards did not take them lightly, and hounds were kept for tracking escapees. This lithograph was drawn by James McClain of the 120th Ohio, another member of which was Joseph Spiegel. After the war, Joseph opened a mercantile store that evolved into Spiegel, one of the leading catalog companies in the United States. James and Joseph were in the final group of prisoners released from Camp Ford. (Courtesy of the Smith County Historical Society.)

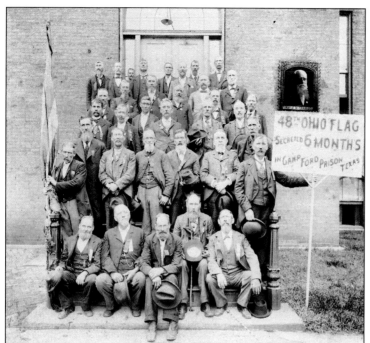

When members of the 48th Ohio Volunteer Infantry were captured in April 1864, they were able to hide their battle colors and secretly keep them during their imprisonment in Camp Ford. When most of the regiment was paroled six months later, the flag left with them. This photograph of 48th Ohio veterans with that flag was possibly taken at a Cincinnati reunion in 1904. (Courtesy of the Smith County Historical Society.)

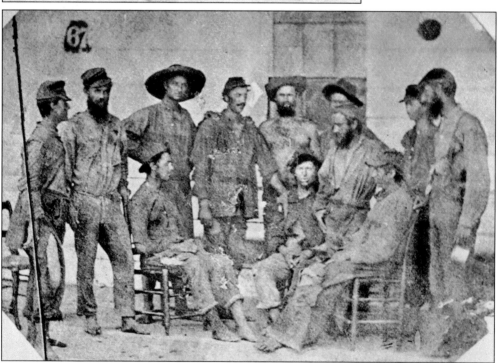

After nine months in Camp Ford, members of the 19th Iowa Infantry were released and arrived in New Orleans in July 1864. Prisoner releases occurred from time to time. A Union prisoner could be exchanged for a Confederate prisoner, with both allowed to return to the ranks, or a prisoner might be paroled if he swore not to take up arms until he was exchanged. (Courtesy of the Library of Congress.)

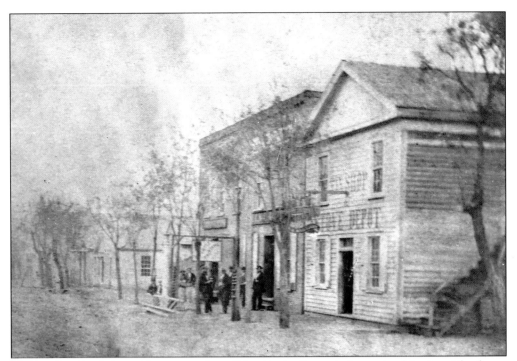

The south side of the public square along West Erwin Street is shown in this view. The frame building to the far right, built by Col. Thomas Erwin in 1860, was located on the southeast corner of the intersection with North College Avenue. This site was the location of Tyler's first post office a few years earlier. (Courtesy of the Smith County Historical Society.)

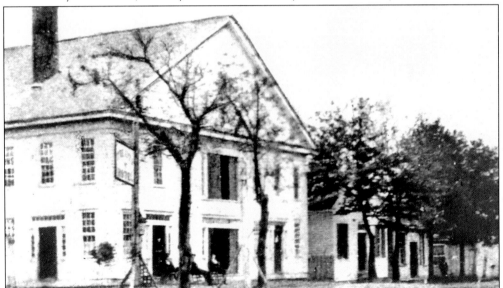

This is the east side of North Spring Avenue. The building to the left was on the southeast corner of the intersection with East Ferguson Street. It was the first hotel in Tyler, built around 1851 as a one-story structure called the Holman House. A second story was added later, and it went through several name changes before burning in 1887. (Courtesy of the Smith County Historical Society.)

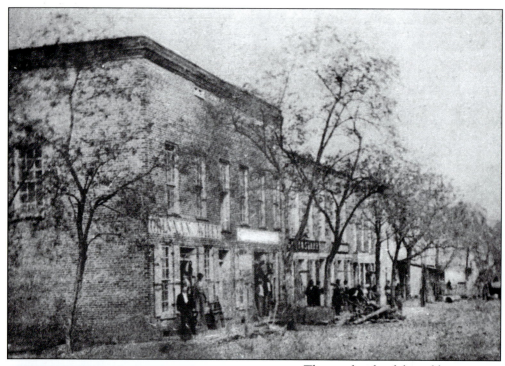

The north side of the public square along West Ferguson Street is shown here. The first building to the left, occupied by Grinnan and Wiley, was located on the northeast corner of the intersection with North College Avenue. (Courtesy of the Smith County Historical Society.)

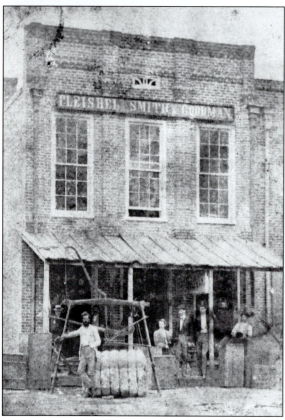

This two-story building housed the mercantile store Fleishel, Smith, and Goodman. Located on North College Avenue around the middle of the west side of the public square, this structure was built after an 1866 fire cleared the site. This store, along with the entire west side of the square, was destroyed by an 1879 fire. The photograph shows a bale of cotton being weighed. (Courtesy of the Smith County Historical Society.)

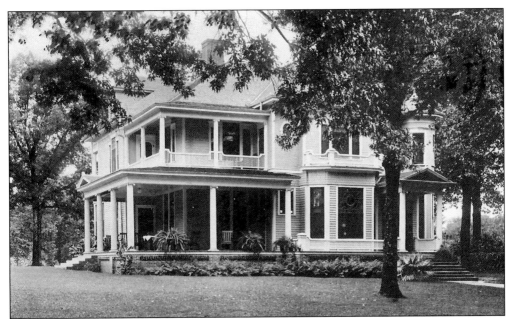

Built around 1872, the John T. Bonner home, shown above, was located at 625 South Vine Avenue. The interior view below is of the drawing room, with the adjoining library in the background. John was an early mayor of Tyler and one of the executives of the Texas Oak Leather Company, which produced the best quality leather goods in the area for half the price of competitors. Their products included saddles, collars, harnesses, and more. (Above, author's collection; below, courtesy of the Smith County Historical Society.)

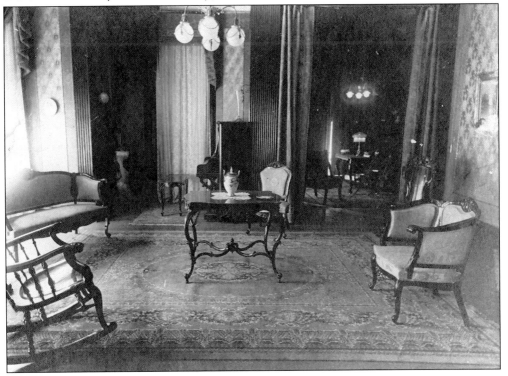

Located at 318 South Fannin Avenue, the Douglas-Holland-Pollard house was built by John B. Douglas in 1873 and enlarged several times over the years. Visible on the porch are, from left to right, Carrie Douglas, John's wife Ketura, Jim Walker, Alexander Douglas, and two unidentified servants. During the Civil War, John served in the Douglas Battery, which was commanded by his brother James. (Courtesy of the Smith County Historical Society.)

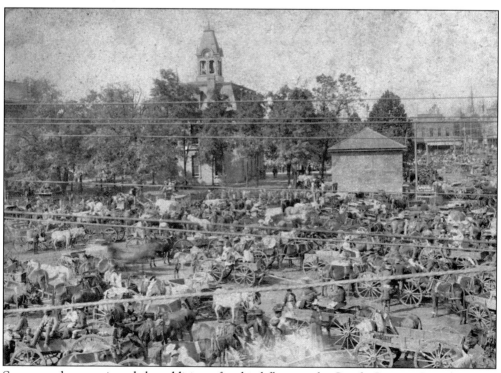

Space needs necessitated the addition of a third floor to the Smith County Courthouse in 1876. A clock tower rising 65 feet above the ground was also added, though no clock was ever installed. In this view of the east side of the courthouse, the 1884 court of appeals building is barely visible to the left, with the 1858 county clerk office to the right. (Courtesy of the Smith County Historical Society.)

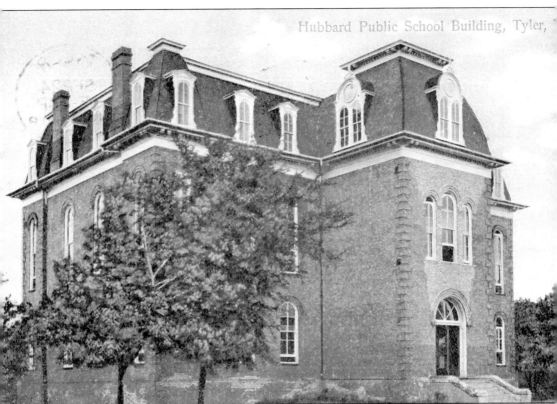

East Texas University, initially a private military school, was built in 1876 facing east at the point where South College Avenue intersects University Place. The military aspect was discontinued in 1879. When sites were being considered for the new University of Texas in 1881, this building, along with its furniture, grounds, and free additional land, was offered to the State of Texas. It was seriously considered, but the final vote gave the state capital, Austin, the university. In August 1882, Tyler School District was formed after a favorable second election to levy a tax to support a public school. The East Texas University building was rented for use as the first public school house and eventually bought in 1886. It was renamed the Hubbard Building after former Texas governor Richard Hubbard, a proponent of public education and a Tyler resident. For a while, it also was called South Side School. The class of 1911 was the last to graduate from the building, and it was demolished in 1913. (Author's collection.)

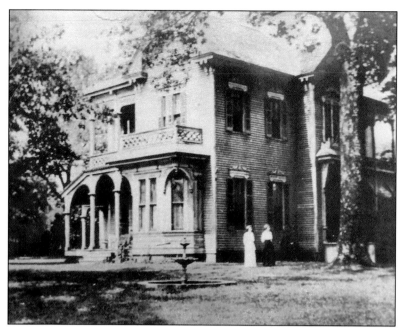

The Bonner-Whitaker-McClendon House is located on the southwest corner of South Vine Avenue and West Houston Street. A short while after Mattie Bonner married attorney Harrison Whitaker, Judge M. H. Bonner, her father and a Texas state supreme court justice, gave them two acres. The couple built their Eastlake Bracketed–style house around 1878, shown in the c. 1900 photograph above. Mattie died in 1892, and Harrison remarried and moved to Beaumont in 1903. The house was rented until Harrison sold it in 1907 to Sidney and Annie McClendon. Annie was Mattie's sister. Four of their children are shown below in the parlor. They are, from left to right, Martha, Frank, Patience, and Annie. Their youngest child, Sarah, who was born in 1910 in the house, became a respected, longtime White House news correspondent. (Both courtesy of the Bonner-Whitaker-McClendon House.)

Two
1880s THROUGH 1900s

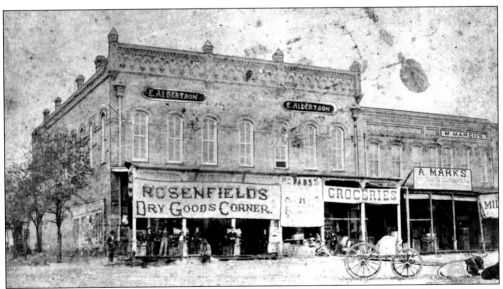

This scene, touched up by the original photographer, shows the west side of North College Avenue, with West Erwin Street passing to the left. All these structures were built after the devastating 1879 fire. The two-story brick building to the left housed the Albertson Opera House on the second floor, which could seat an audience of 600, and also was a venue for church services and graduation ceremonies. (Courtesy of the Smith County Historical Society.)

BERGFELD'S,

THE FAVORITE

RESORT,

North Side of the Square,

TYLER, TEX.

The Most Elegantly Fitted up Saloon in East Texas.

The Best of Wines, Liquors, Beer, Cigars and Tobaccos.

POOL AND BILLIARD TABLES.

Strangers and Patrons Always Welcome.

Born in 1855 in St. Louis, Missouri, Rudolph Bergfeld moved to Tyler in 1878. He opened Bergfeld's Resort, located on the north side of East Ferguson Street just east of the intersection with North Broadway Avenue. It became one of the city's most popular saloons. This advertisement is from the 1882 City Directory. Rudolph went on to make his fortune in real estate and commercial development. Saloons continued to proliferate, and many were considered violent places. After a local crusade, reformers closed the Tyler saloons in 1901, long before the nation's Prohibition Amendment went into effect in 1920. After the 1933 repeal of that amendment, Smith County voted to allow 3.2 percent beer and wine. "Honky-tonk" clubs became commonplace in the city, but in 1939 voters restored prohibition to the county. (Courtesy of the Smith County Historical Society.)

Mass was celebrated in 1878 for the first time in Tyler, which was then in the Diocese of Galveston. The first church to house Immaculate Conception Catholic Church, located on the northeast corner of North College Avenue and West Locust Street, was dedicated in 1882 and is shown on this postcard. Rev. J. S. Chaland served as the first pastor. (Author's collection.)

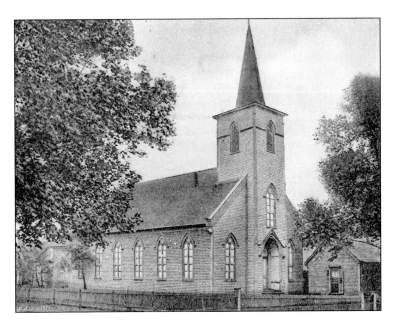

Percival V. Pennybacker became the third school district superintendent in 1884. He offered the high school principal position to an old classmate, Anna Hardwicke, who accepted and also taught history. They brought order and stability to the young school district and soon married. In this photograph of the class of 1884, Percival is seated in the center, with Anna standing to the back left. (Courtesy of the Smith County Historical Society.)

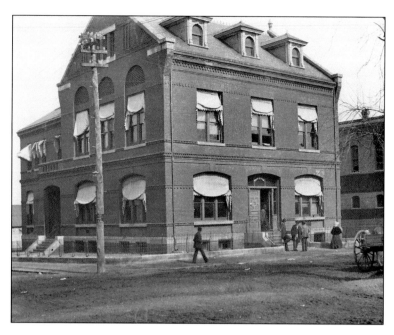

Built in 1886, the Federal Building was located on the northeast corner of North Bois D'Arc Avenue and West Ferguson Street. The post office occupied the ground floor, while federal courtrooms were on the second floor. A 1908 expansion extended both floors to the north and shifted the front door to the left. (Courtesy of the Smith County Historical Society.)

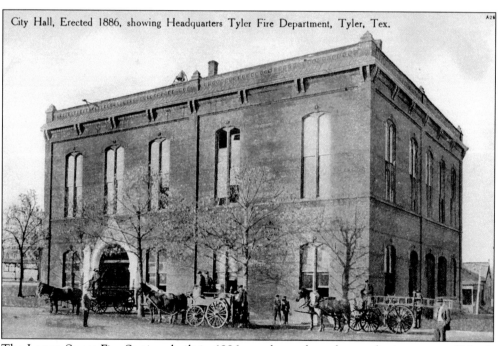

The Locust Street Fire Station, built in 1886, was located on the northwest corner of North College Avenue and West Locust Street. At times it was concurrently occupied by city hall, the police station, schools, and more. The structure was reportedly listed in *Ripley's Believe It or Not* as the "world's tallest two-story building," for it was 40 feet tall, enough height for four stories. (Author's collection.)

Murphey the Jeweler has always operated as a family business and reportedly is one of the oldest retail establishments still open for business in East Texas. It opened in Tyler in January 1868 on the northeast corner of North Broadway Avenue and East Ferguson Street. This is an advertisement from the 1887 City Directory. (Courtesy of the Smith County Historical Society.)

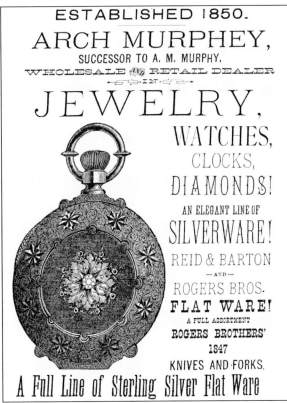

The Horace Chilton family home, shown shortly after construction in 1888, was located at 727 South Chilton Avenue. Born near Tyler in 1853, Horace was the first native Texan to serve in the United States Congress. After a series of owners, D. K. Caldwell bought the house in 1955, and it became Caldwell Play School No. 2 until it closed in 1998. (Courtesy of the Smith County Historical Society.)

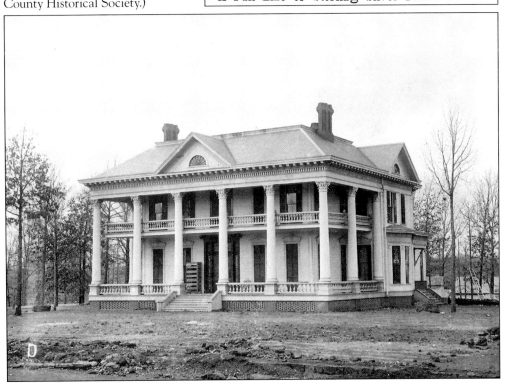

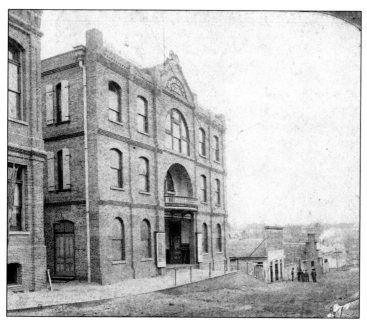

The Grand Opera House stood on the east side of South Spring Avenue, just south of East Erwin Street. It was destroyed by fire twice. The original structure opened in November 1888 and was lost a month later. The second structure, shown in the photograph, opened in 1889 and was destroyed in April 1907, never to be rebuilt. It saw such performers as the famous Sarah Bernhardt. (Courtesy of the Smith County Historical Society.)

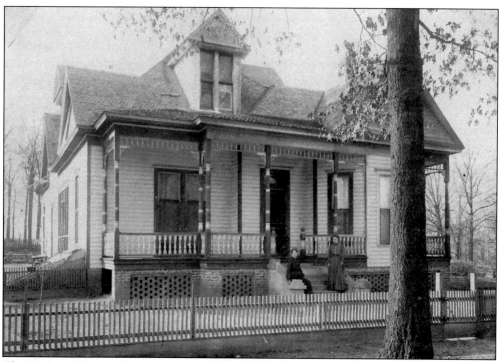

The Mathis-Albertson home was originally built by James Martin Mathis in 1889 as a two-room house for himself and his wife, Eliza, and it was expanded over the years. Otto Albertson married their daughter Hattie Mathis in the parlor in 1910, and they moved in with her parents in 1923. (Courtesy of the Smith County Historical Society.)

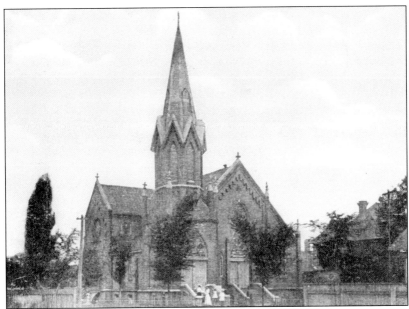

First Baptist Church organized in 1848 and was officially chartered in 1882. The first structure to house this congregation was built in 1855 on East Ferguson Street. It burned, as did the second building constructed. The third building was a red brick structure dedicated in 1889, located on the southwest corner of North Bois D'Arc Avenue and West Locust Street. The postcard above shows this church, while the photograph below shows the interior during the November 3, 1897, wedding of Arthur R. Wood and Florence Human, officiated by A. J. Fawcett. The church continued to use this building until moving in 1913. It continued to be used for many years by various businesses and was eventually demolished in 1959 to make way for a new church education building. (Above, author's collection; below, courtesy of the Smith County Historical Society.)

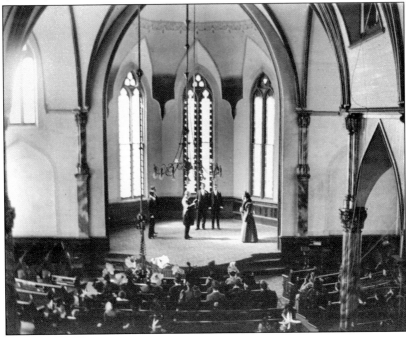

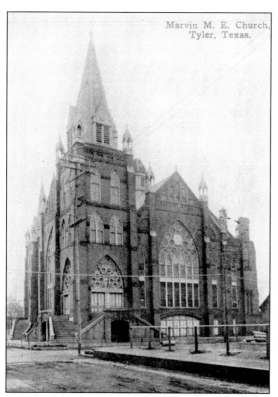

At first, Christians met during a union church service in the log cabin county courthouse. Methodists formed a separate church in 1848 and moved their meetings to a blacksmith shop. Soon the church reorganized under the name Methodist Episcopal Church South at Tyler. In a joint effort with the St. John's Masonic Lodge, the church erected a two-story frame building on the southeast corner of South Bois D'Arc Avenue and West Erwin Street in 1852. Construction started on a new location on the southwest corner of the same intersection in 1890. A year later, the organization changed its name to Marvin Methodist Church. The postcard at left shows this location, while the *c.* 1890 photograph below faces the altar, decorated for the wedding of John Burk and Nettie Baker. (At left, author's collection; below, courtesy of the Smith County Historical Society.)

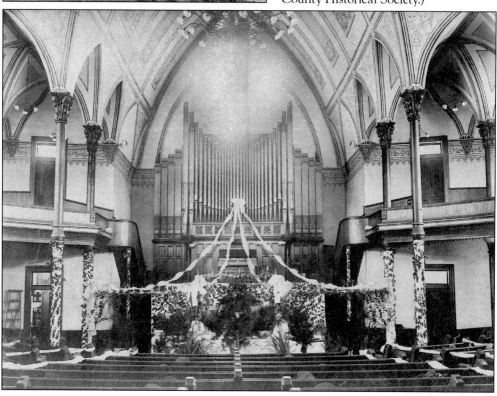

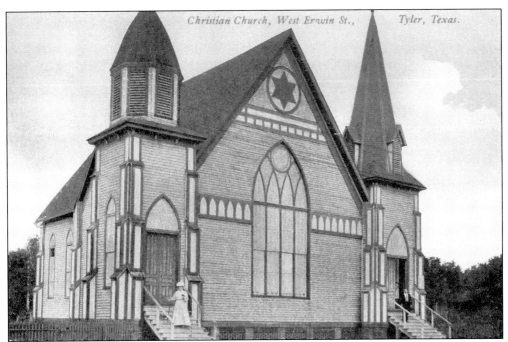

The Christian Society starting meeting in private homes in 1888. As members increased, their meetings moved to the Albertson Opera House. In 1889, the group officially organized itself as the First Christian Church. In 1893, the congregation moved into their new home located at 401 West Erwin Street, shown in the above postcard. The 1907 photograph below shows the Primary Department on the east entrance church steps. The woman standing second from the right is Mrs. J. J. Lockhart, one of the class teachers, as well as the wife of the pastor. (Above, author's collection; below, courtesy of the Smith County Historical Society.)

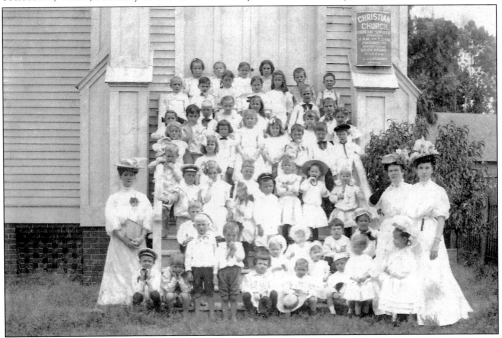

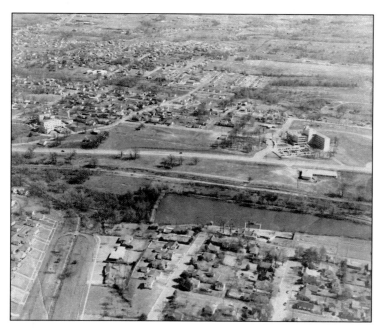

Springs and wells were the original water supply for Tyler. Next was Victory Lake, created by a dam on Turtle Creek, followed by Lake Bellwood. The locations of Mother Francis Hospital and Medical Center Hospital in this aerial photograph give a clue to the location of long-gone Victory Lake. Lake Street and Victory Drive were so named due their proximity to this lake. (Courtesy of the Smith County Historical Society.)

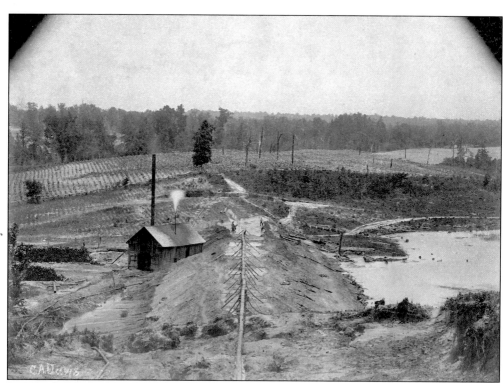

In 1894, a dam built across Indian Creek west of town created the 170-acre Lake Bellwood to supplement the water supply. Public Works Administration workers raised the spillway by two feet in 1936, making two million more gallons of water per day available to the city. In 1965, the Lake Bellwood treatment facilities were retired. Shown is construction of the hydraulic fill dam. (Courtesy of the Smith County Historical Society.)

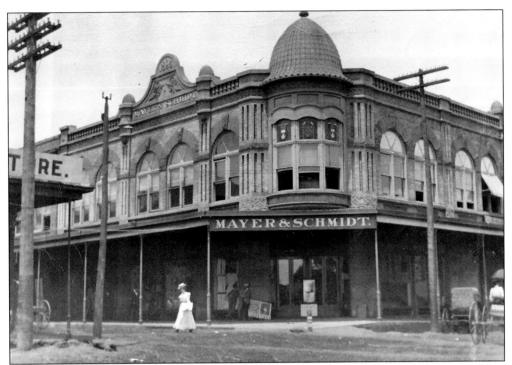

In 1889, Jewish German immigrants Abraham Mayer and John Schmidt bought out the E. Frankfort store located on the northwest corner of North College Avenue and West Erwin Street. They built a new store, shown above, on the northwest corner of North College Avenue and West Ferguson Street and moved in 1894. In 1937, the store underwent modernization inside and out, shown below. William Dillard, who wanted to expand from his single store in Texarkana, bought out Mayer and Schmidt in 1956. The downtown location continued to operate under the old name until 1974, when the store relocated to the new Broadway Square Mall and changed its name to that of William's store chain, Dillard's, which had grown considerably since Mayer and Schmidt became the second store. (Both courtesy of the Smith County Historical Society.)

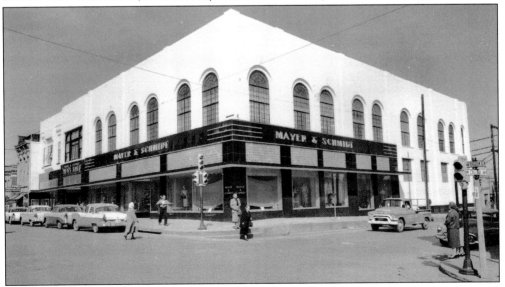

TEXAS COLLEGE

IN TYLER

"The Heart of East Texas"

Is the Only
ACCREDITED SENIOR COLLEGE
In Smith County

A Class A College for the Training of the Negro Youth

Courses Offered in the Liberal Arts, Sciences, Physical Education, Public School Music and Education which lead to the

BACHELOR OF ARTS DEGREE AND
TEACHERS CERTIFICATES

For Further Information, Address
D. R. GLASS, President

Texas College, located at 2404 North Grand Avenue, was founded in 1894 as part of the educational ministry of the Colored Methodist Episcopal Church. Originally it offered elementary, agricultural, mechanical, and normal courses, but it started a college department in 1905. It became a fully accredited junior college in 1924, followed in 1932 by a senior college accreditation. A 1930s advertisement is shown. (Courtesy of the Smith County Historical Society.)

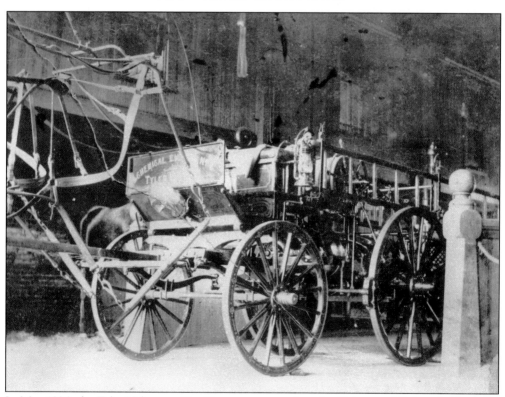

In May 1896, the Tyler Volunteer Fire Department purchased a Bishop and Babcock Chemical Engine for $2,230, shown here at the Locust Street Fire Station. Christened by the department as Chemical Engine 1, it was equipped with two 35-gallon chemical tanks and 200 feet of hose. Harnesses hung from the ceiling, ready to be dropped onto the horses. (Courtesy of the Smith County Historical Society.)

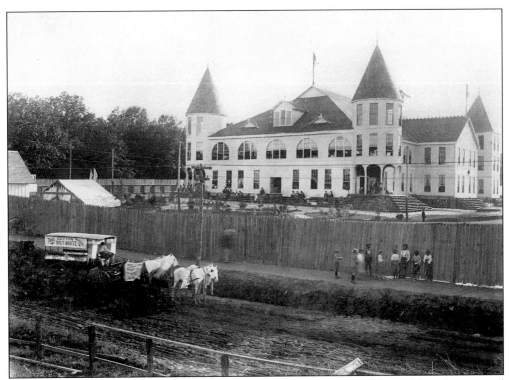

In 1895, the Texas Fruit Palace was built on the northwest corner of South Vine Avenue and West Front Street by local businessmen to showcase Texas fruit production. It hosted annual two-week-long expositions so lavish that the group went bankrupt after the second event in 1896. The view shows the east side of the building from across a then-unpaved Vine Avenue. (Courtesy of the Smith County Historical Society.)

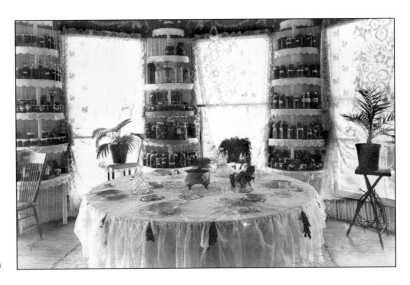

Here is a Texas Fruit Palace pickling and preserves exhibit. It was located on the east end of the second floor in one of the two 8-foot round towers. The first floor of each of these towers housed a ticket office. (Courtesy of the Smith County Historical Society.)

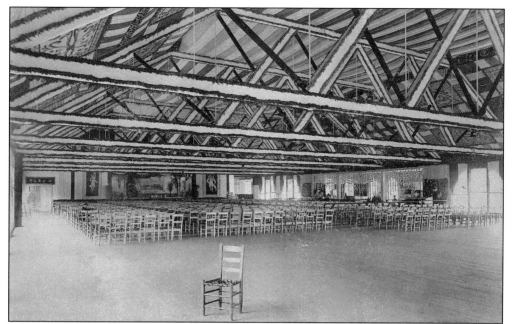

The second floor of the Texas Fruit Palace was dominated by a 5,000-seat auditorium, with a stage at the west end, as shown in the above image. During the Second Annual Exposition in July 1896, this was the site of music day and night, including performances by Mexico's famous Fourth Cavalry Band and a daily grand opera by a company of stars from Chicago and New York City. The Fourth Cavalry Band appears in the view below with Minnie Jester, a popular local vocalist. (Both courtesy of the Smith County Historical Society.)

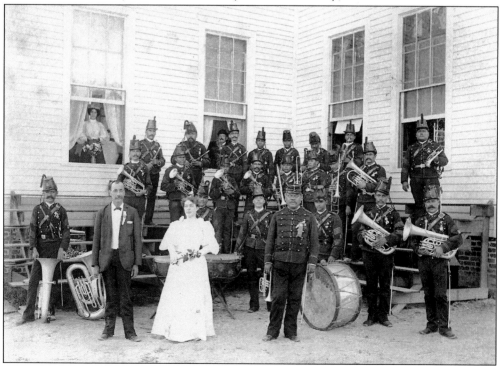

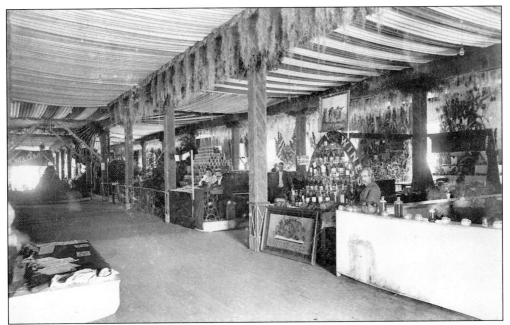

For the Second Annual Exposition held in July 1896, the main exhibit hall on the first floor of the Texas Fruit Palace was decorated with fruits and flowers under the guidance of Sam Pope, a World's Fair decorator. The view includes exhibitors of native wines and Starr Pianos. (Courtesy of the Smith County Historical Society.)

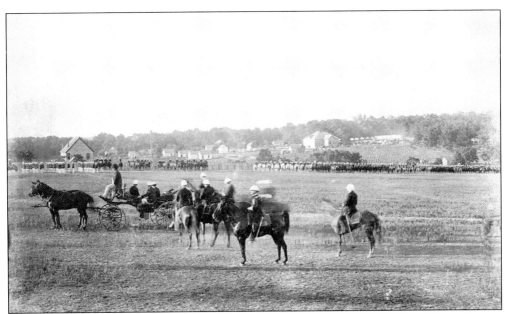

Texas Volunteer Guards, as well as Federal troops, participated in the Grand State Encampment held during the Texas Fruit Palace 1896 Exposition. Daily drill competitions were put on for $15,000 in prizes. One unit, composed of 34 high school cadets from the West Texas Military Academy in San Antonio, was under the command of a 16-year-old Douglas MacArthur. (Courtesy of the Smith County Historical Society.)

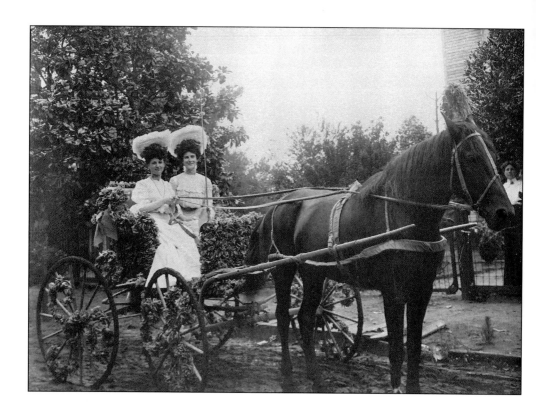

The Battle of the Roses, held during the Texas Fruit Palace Second Annual Exposition, is considered by some to be Tyler's first Rose Parade. On July 27, 1896, twenty thousand spectators gathered on the public square to watch the two columns of decorated horse-drawn carriages and floats pass each other, throwing roses and other flowers at each other. In the end, each side surrendered to the other. (Both courtesy of the Smith County Historical Society.)

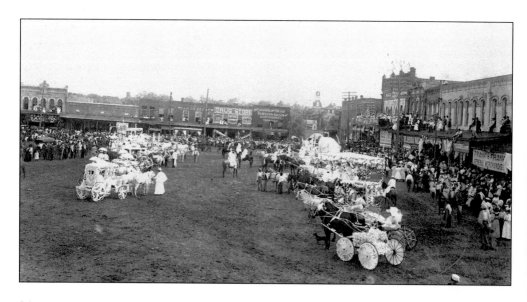

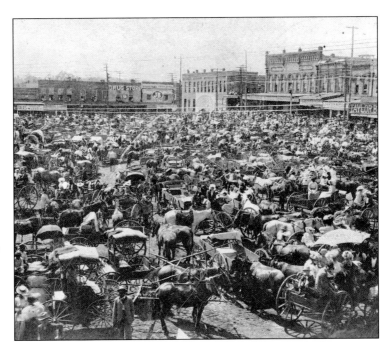

The southwest corner of the public square appears in this 1897 photograph, which looks across a crowded square towards the intersection of North College Avenue and West Erwin Street. Businesses seen along Erwin Street include L. Robbins Saloon and K. Marmar Liquor House, a scene out of place for a now-dry Smith County. The Lipstate's store is at the corner facing east. (Courtesy of the Smith County Historical Society.)

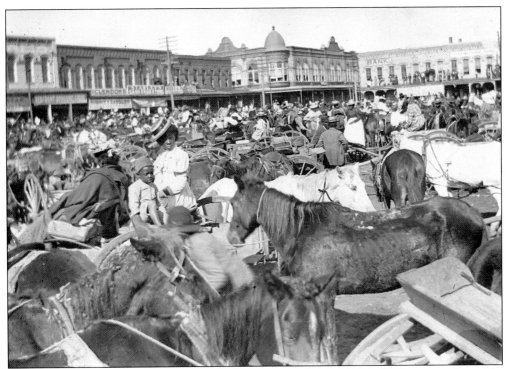

This photograph of "Circus Day," taken November 20, 1897, looks northwest across the public square towards the intersection of North College Avenue and West Ferguson Street. The crowd is awaiting the procession around the square. The Mayer and Schmidt store is in the middle of the photograph on the northwest corner of the intersection. (Courtesy of the Smith County Historical Society.)

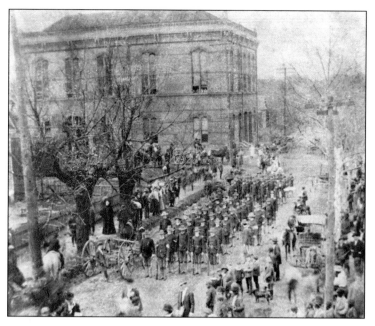

Shortly after the start of the Spanish-American War in April 1898, Tyler lawyer Hampson Gary organized the Smith County Rifles, which reported to Camp Tom Ball in July. They never saw action before the short war ended in August and were discharged in March 1899. The company is seen on North College Avenue, most likely in a parade taking place upon their return home. (Courtesy of the Smith County Historical Society.)

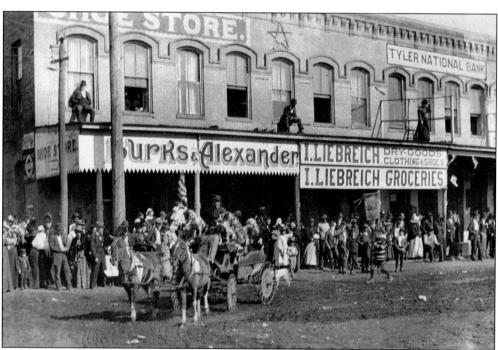

This photograph of Gentry's Dog and Pony Circus parade, taken November 7, 1898, shows the procession as it turns south off West Ferguson Street onto North College Avenue. The wagon is full of an assortment of dogs. Businesses shown along Ferguson Street include Tyler National Bank, which would eventually evolve into Peoples National Bank. (Courtesy of the Smith County Historical Society.)

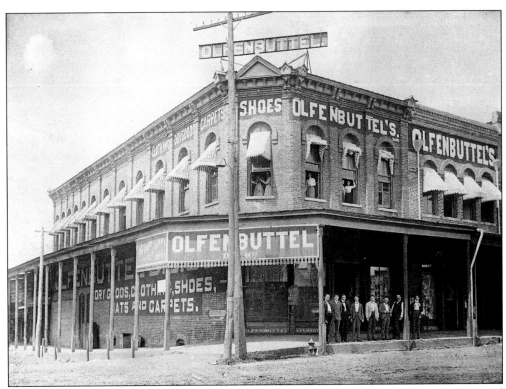

When Mayer and Schmidt opened in 1889, August Olfenbuttel was manager, and the store operated under his name. When he left the company in 1897, the store then operated under the name Mayer and Schmidt. August operated his own department store for a period called Olfenbuttel and Company, located on the northeast corner of North Broadway Avenue and East Ferguson Street. (Courtesy of the Smith County Historical Society.)

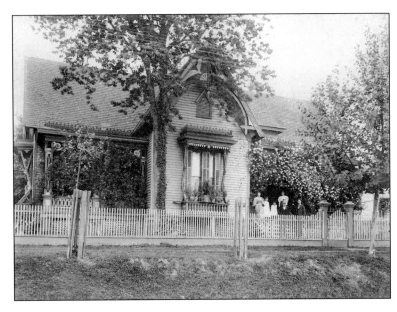

The Episcopal rectory was located at 115 South Bois D'Arc Avenue. It is shown in this 1890s photograph with its occupants, Rev. Hugh G. Scudday and family, standing on the front stairs of its rose-vine-covered porch. (Courtesy of the Smith County Historical Society.)

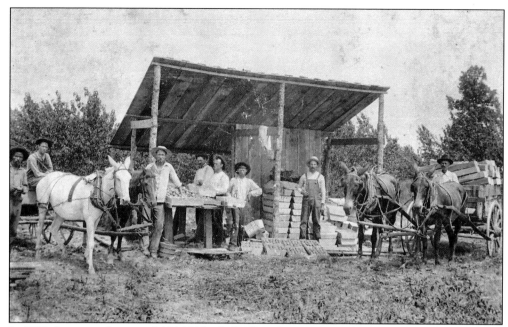

In 1889, the county harvested 104,283 bushels of peaches. In the mid-1890s, the Texas Fruit Palace held expositions promoting the fruit industry, but disaster soon came. San Jose scale, a major peach blight, struck and completely killed all the peach orchards by 1914. Most peach growers switched to the growing rose industry. This c. 1900 view shows peaches being packed. (Courtesy of the Smith County Historical Society.)

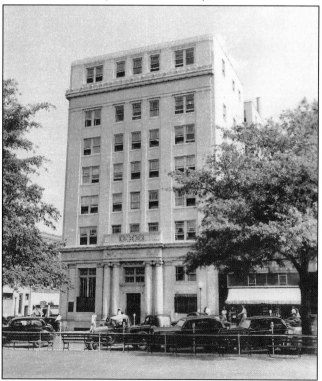

Citizens National Bank opened on June 2, 1900. In 1908, it merged with two other banks and moved to the northeast corner of North Broadway Avenue and East Ferguson Street. In 1924, the bank built an eight-story building at this location, shown here. In February 1980, this building became the first in Tyler to be imploded. (Courtesy of the Smith County Historical Society.)

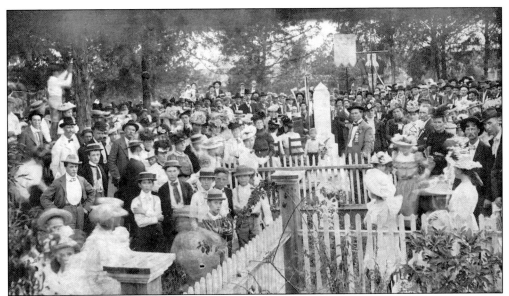

When William F. Griffin died in 1901, fellow members of the Woodmen of the World, Orchard Camp No. 72, gathered at his grave in Oakwood Cemetery to honor him and dedicate his tombstone. The local camp was organized during the 1890s. (Courtesy of the Smith County Historical Society.)

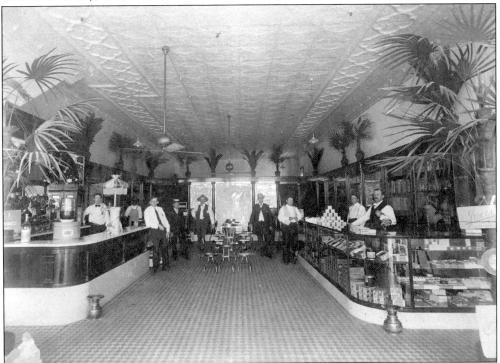

This early-1900s view is of the Coker Drug Company on the southwest corner of North College Avenue and West Ferguson Street. Charles A. Coker, to the far right, was the owner. A soda fountain is to the left, a usual component of a drugstore in the past. (Courtesy of the Smith County Historical Society.)

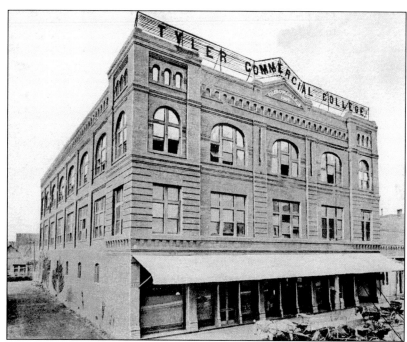

During a demand for trained school teachers in the late 1890s, Tyler College formed to compete with the state-supported "normal colleges," where public school teachers could receive scholarships. It was originally housed in the Texas Fruit Palace, but after a 1903 fire destroyed the building, the school built a new facility in 1904 on South College Avenue, shown above, and renamed itself Tyler Commercial College. For many years the college advertised itself as "the largest business training school in America." Below is a view of the student body, gathered in front of the Carnegie Public Library (left) and the college. In 1913, the building was doubled in size. In 1955, the college moved to a smaller location, and the old building was demolished in 1965 for the drive-through Peoples National Bank. (Both author's collection.)

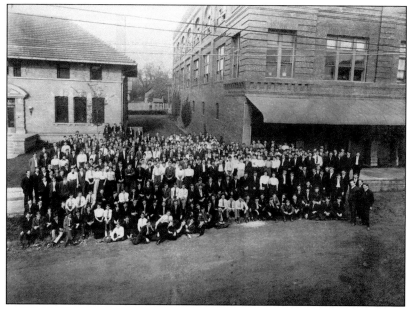

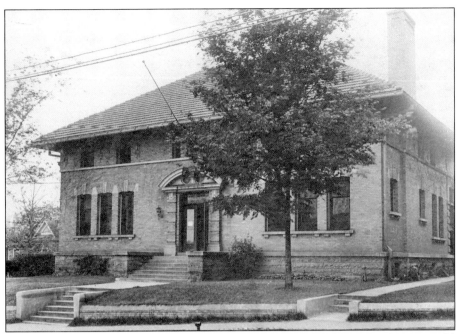

A library existed in Tyler at various locations since the 1890s, first as a subscription library, but it was converted to a free public one in 1901. Andrew Carnegie, from a poor Scottish family that immigrated to the United States in 1848, became a powerful businessman in the American steel industry. He spent his last years as a philanthropist, which included building over 2,500 libraries worldwide. Tyler received a $15,000 donation from Carnegie to build a new home for its library. Private funds were used to buy the lot, furnishings, and landscaping. It was completed in 1904 on the northwest corner of South College Avenue and West Elm Street. In 1936, an expansion on the west side doubled its size. The library moved to a new building south across the street in 1980. (Both courtesy of the Tyler Public Library.)

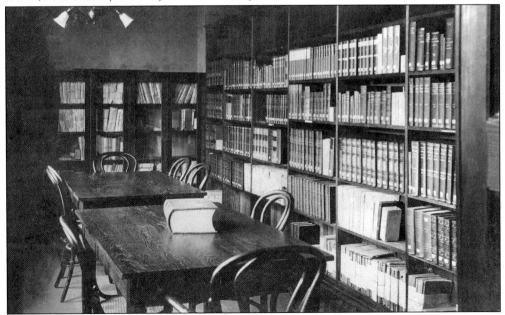

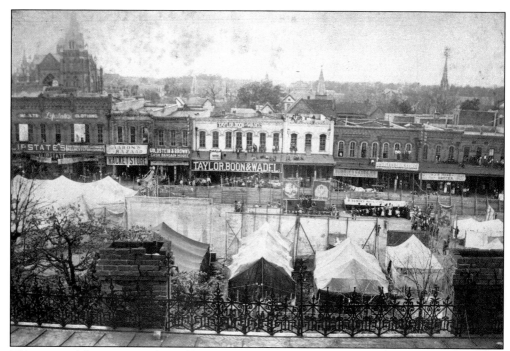

These views of a circus on the public square in 1904 were taken from atop the Smith County Courthouse. The above view looks west across circus tents at the businesses along North College Avenue. The Lipstate's store is to the far left, with Marvin Methodist Church beyond it. Other businesses visible include Aaron's Bazaar, Goldstein and Brown's, Taylor, Boon and Wadel, Starley's Drug Store, and J. D. Irons Grocer. The below view looks northwest, with the roof of the county and district clerks' offices, built in 1884, appearing in the right foreground. Beyond the circus midway, the Mayer and Schmidt store is seen on the far corner of North College Avenue and West Ferguson Street, with the First Baptist Church steeple beyond it. (Both courtesy of the Smith County Historical Society.)

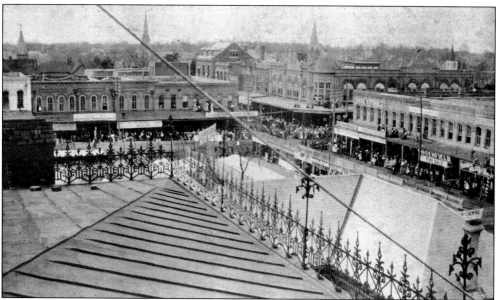

Dallas attorney M. M. Crain speaks from the north porch of the courthouse to a crowd gathered on the public square in this 1904 photograph. The brick building in the near background is the first county clerk office, built in 1858. In the far background, businesses along East Ferguson Street and North Spring Avenue are visible. (Courtesy of the Smith County Historical Society.)

In 1905, the East Texas Baptist Academy was founded and built on the southeast corner of South Lyons Avenue and Bellwood Road. Originally a combination elementary and high school, in 1924 it was granted junior college status and renamed Butler College. In 1949, it was approved as an accredited four-year liberal arts college. It closed in May 1971. A 1930s advertisement is shown at right. (Courtesy of the Smith County Historical Society.)

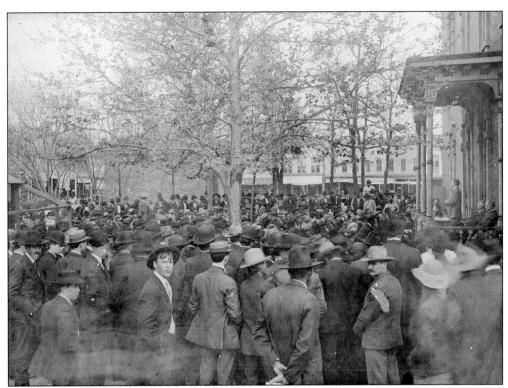

BUTLER COLLEGE

ISAIAH JACKSON, President

A School of Higher Education for the Negro Youth

JUNIOR COLLEGE

Accredited by State Board of Education

Catalogues Sent on Request

Phone 616 P. O. Box 1139 Tyler, Texas

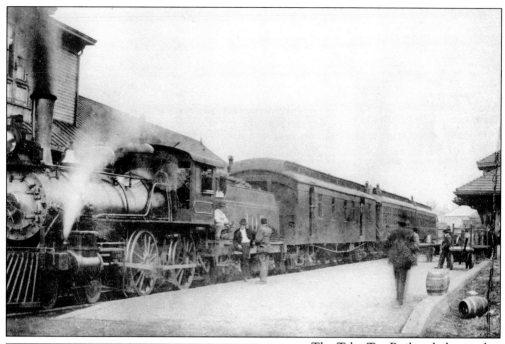

The Tyler Tap Railroad, destined to become the oldest section of the Cotton Belt Railroad, was put in operation in 1877. The Cotton Belt Depot, located at 210 East Oakwood Street, was opened in 1905 as a passenger depot. The last passenger train passed through Tyler in April 1956, and the depot was donated to the city in the late 1980s. (Courtesy of the Smith County Historical Society.)

Cely Lipscomb, "Aunt Cely" to the Goodman family, lived in their home as the cook, originally as a slave but later as a free woman. She tended to Dr. Samuel Goodman during his last years, and he left a fund for her in his will. This photograph shows Cely (left) and Sallie Goodman LeGrand in 1905. Cely died in 1906 at the age of 100. (Courtesy of the Smith County Historical Society.)

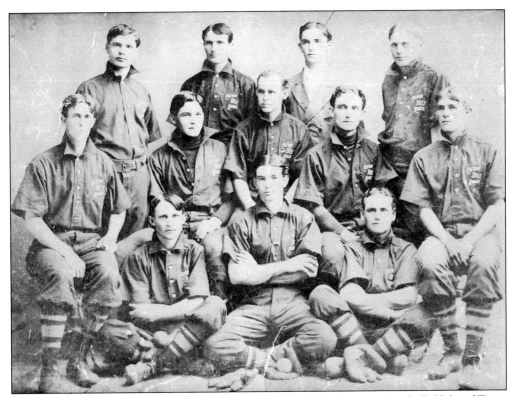

Shown is the Cotton Belt baseball team, who were the 1906 Amateur Baseball Clubs of Texas champions. Only their last names are given, except for a few whose first names were known. From left to right they are (first row) Tom Johnson, Gaffield, and Switzer; (second row) Douglas, H. Bonner, Fred Morris, Burke, and Evers; (third row) Tom Bonner, Capps, Harrington, and Hewitt. (Courtesy of the Smith County Historical Society.)

On January 1, 1908, the paid fire department began operation, though still assisted by a larger volunteer force. The members of the paid department in 1911 are, from left to right, (seated) assistant chief M. P. Burns, Deppo Day, and Roy E. Owens; (standing) Ed Lytle, Eugene Seay, Clyde Loving, and Chief Joseph J. Daglish. (Courtesy of the Smith County Historical Society.)

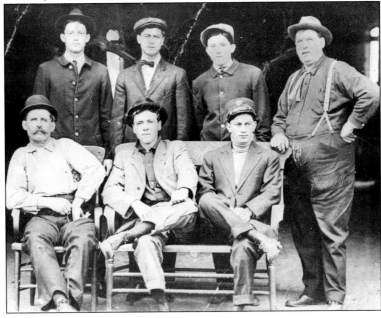

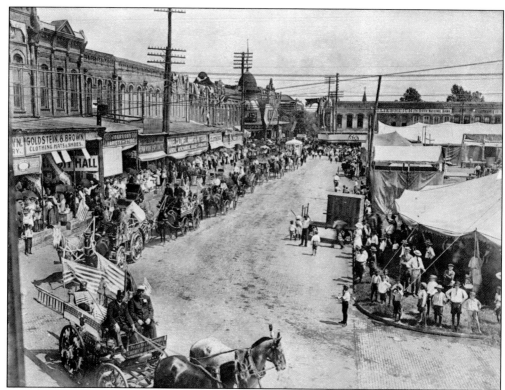

Shown is the Homecoming Week Parade held on July 6, 1909. The parade is headed south on North College Avenue, turning east onto West Erwin Street. Horse-drawn wagons from the fire department are in the lead. (Courtesy of the Smith County Historical Society.)

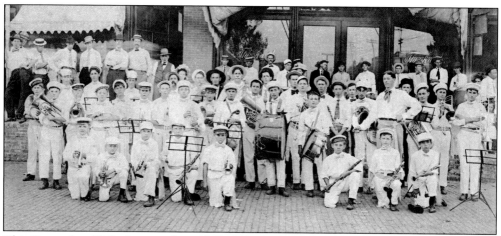

This September 1909 photograph is of the Tyler Kid Band. This brass military band of Tyler youth was formed around the turn of the 20th century. Not only did they perform locally, but they were also very popular at Confederate veteran reunions all across the South. "Doc" Witt became their bandmaster in 1908. Due to aging, in 1916 the group became the Tyler Municipal Band. (Courtesy of the Smith County Historical Society.)

Three
1910s THROUGH 1930s

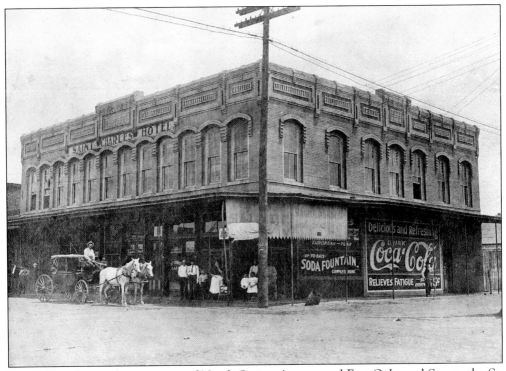

Located on the southwest corner of North Spring Avenue and East Oakwood Street, the St. Charles Hotel was conveniently located across the street from the Cotton Belt Depot. Among the amenities, the hotel had a saloon, café, and ladies dining hall. It closed in the late 1940s, and the building was demolished in the 1970s. (Courtesy of the Smith County Historical Society.)

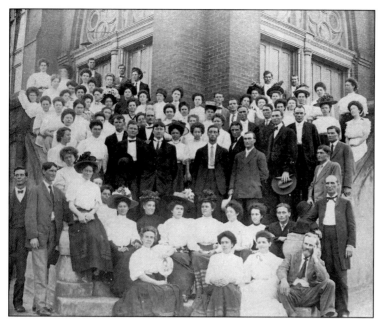

This c. 1910 photograph shows the Marvin Church Teachers Institute class on the church steps, including Professor A. W. Orr, the seated man with a beard to the front right. These steps, which served originally as entrances to the second floor level, were later removed. (Courtesy of the Smith County Historical Society.)

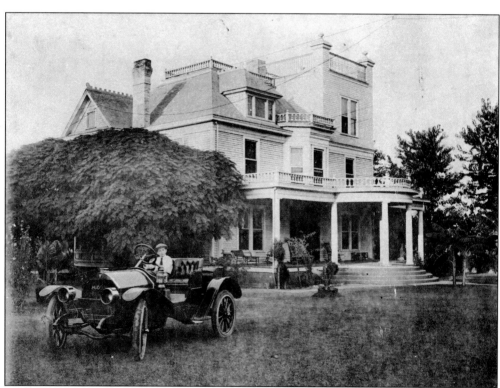

Originally located at 431 West Ferguson Street, this was the home of the Dr. A. P. Baldwin family. Later the house was moved to the northeast corner of North Bonner Avenue and West Locust Street, where it served as city hall until a new one was constructed in 1939. During World War II, it served as a USO. The house was eventually demolished around 1970. (Courtesy of the Smith County Historical Society.)

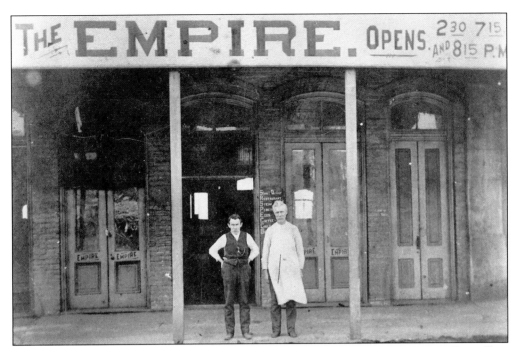

Located at 109 East Erwin Street, the Empire Café was owned by Mac C. Boron. Basically a short-order restaurant, it was only open for a few years. Mac (left) is joined in front of the café by Stephen Elliott, his cook. (Courtesy of the Smith County Historical Society.)

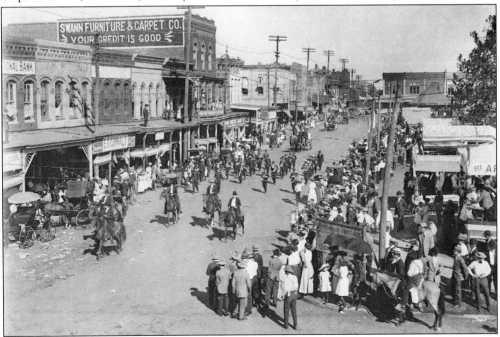

This view, looking east on East Ferguson Street, is of a parade making its way around the courthouse square. Horses lead the way, followed by a band and decorated wagons and automobiles. With the tents along the right and a carousel at the far end, this is most likely one of the East Texas Fairs held on the square in the early 1910s. (Courtesy of the Smith County Historical Society.)

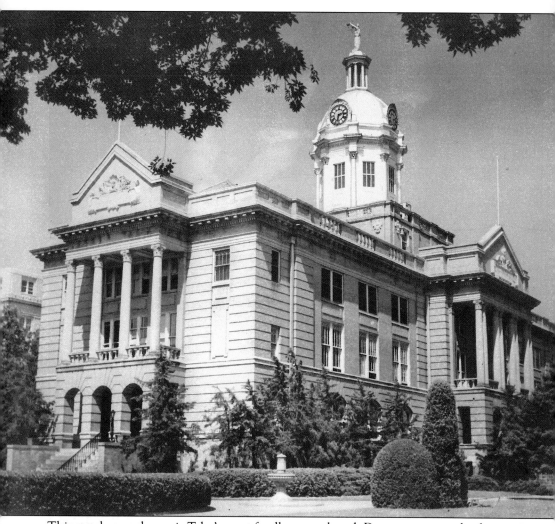

This stately courthouse is Tyler's most fondly remembered. Due to space needs, the previous courthouse was razed, and the cornerstone for this new building was dedicated in July 1909 at the same site. By November, the 11-foot-tall copper statue of Themis, the Greek goddess of law and justice, was lifted atop the 36-foot-diameter rotunda after being hugged by several onlookers. The four clock faces were not installed until early the next year. The new courthouse was occupied in May 1910, but it was not formally dedicated until October 6, 1910. The 165-foot-tall structure cost $165,000 and was designed by Austin architect Charles H. Page, who also designed five other courthouses in Texas. Several reasons, the main of which being a desire to cut Broadway Avenue through the square, led to its demolition, which started on September 29, 1955. When the statue of Themis was lifted to the ground from atop the rotunda, once again she was greeted with hugs. (Courtesy of the Smith County Historical Society.)

The photograph at right shows the county courthouse staircase, located directly under the rotunda, which went to all three above-ground floors. Daylight is streaming in from a hallway leading to the south entrance. The stairs to the left led to the county court, while those to the right led to the district court. The below view is of the district courtroom, which occupied the top two floors of the west end of the courthouse. The bench can be seen in the center, with the witness stand to the right. Out of view further to the right is the jury box. A balcony overlooked this courtroom. The judge's chambers were beyond the three windows behind the bench. (Both courtesy of the Smith County Historical Society.)

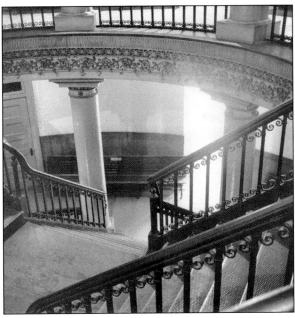

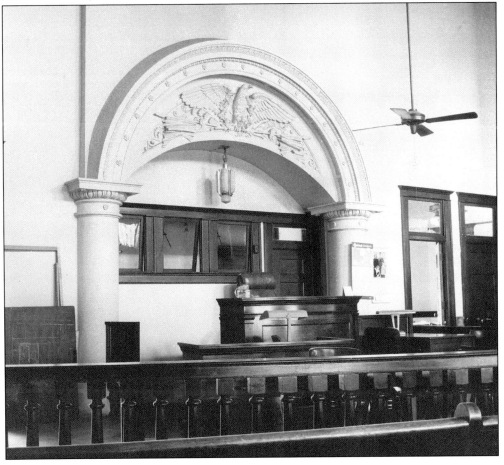

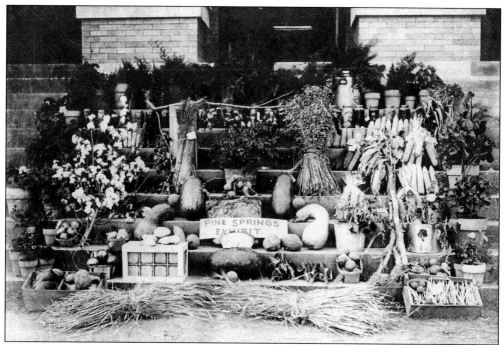

Tyler held its first fair in 1876, but following fairs were only held sporadically. In 1910, the East Texas Fair Association was organized, and fairs became annual events. For the first two years, the fair was held downtown on the courthouse square. The 1910 fair was held from October 6 through 8 and included agricultural exhibits on the courthouse stairs, such as the one shown above by the Pine Springs community. Even though the fair was no longer held downtown after 1911, the opening-day parades continued to circle the square for years. The view below shows the October 3, 1914, fair parade as it passes the courthouse along East Ferguson Street. (Both courtesy of the Smith County Historical Society.)

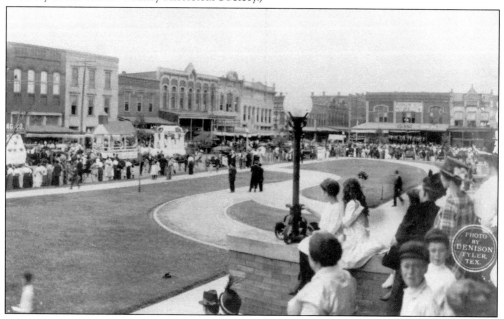

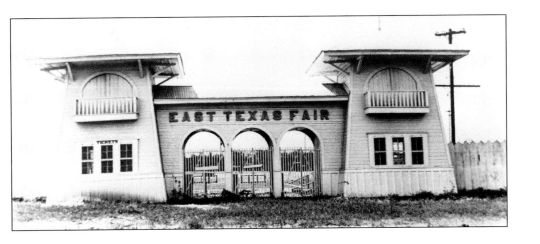

In 1912, the East Texas Fair Association purchased 75.2 acres from the William Herndon estate for $4,500 for use as its own permanent site. The first fair to use the new grounds was held October 6–8, 1912. Included in the festivities were exhibits, rides, fireworks, hot-air balloon ascensions, as well as horse and automobile races. In time for the 1913 fair, the city extended electricity to the fairgrounds, as well as streetcar service. In 2005, the fair association purchased acreage outside of West Loop 323, with future plans to move the event, now known as the East Texas State Fair, to the much larger venue. The 1930s view above shows an early main gate with ticket windows at the fairgrounds. The aerial view below shows the fairgrounds during the 1938 event. (Both courtesy of the Smith County Historical Society.)

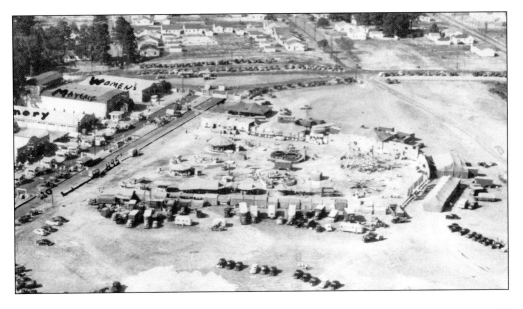

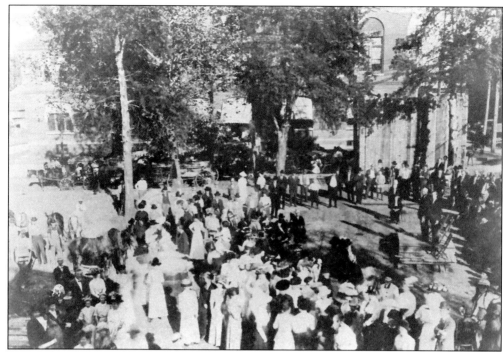

The groundbreaking ceremony for a new First Baptist church was held on October 18, 1911, as shown above. With the 1886 Federal Building visible in the background through the trees, the ceremony was presided over by Dr. G. L. Yates, standing on the stage to the right. In March 1913, the congregation moved into the new building, located at 301 West Ferguson Street, immediately south of their 1889 building. The new church is shown below, and immediately to the left is the Lillie Belle Wright Education Building, completed in 1935. A radio ministry began in 1947, and television broadcast of services started in 1965. (Both courtesy of the Smith County Historical Society.)

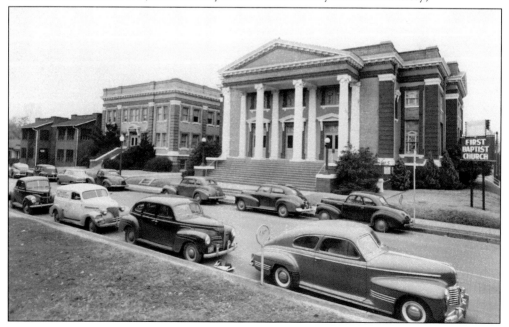

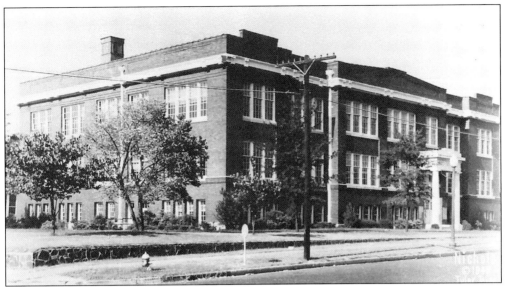

Located on the northwest corner of South College Avenue and West Front Street, Tyler High School was built in 1912. When Robert E. Lee Junior-Senior High School opened in 1958, Tyler High School was renamed John Tyler High School. The buildings were abandoned when John Tyler moved to West Loop 323 in the 1960s. The building shown was demolished, and the school district now uses the remaining buildings for Caldwell Elementary Arts Academy. (Author's collection.)

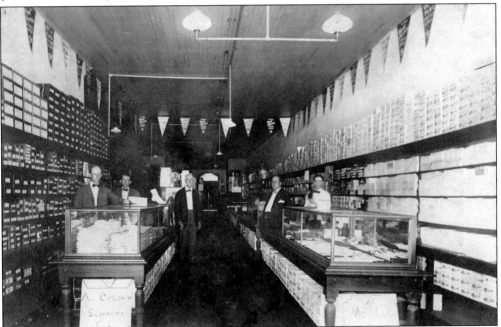

E. Albertson and Sons was a shoe store, but work clothes were sold there as well. Elif Albertson and his brother Tom moved to Tyler from Norway in the 1850s. Elif and his sons Otto, Robert, and Harry opened this store, shown around 1912. In the view are, from left to right, Otto, Harry, Elif, S. N. Zemansky, and Robert. Bankruptcy closed the store in 1933. (Courtesy of the Smith County Historical Society.)

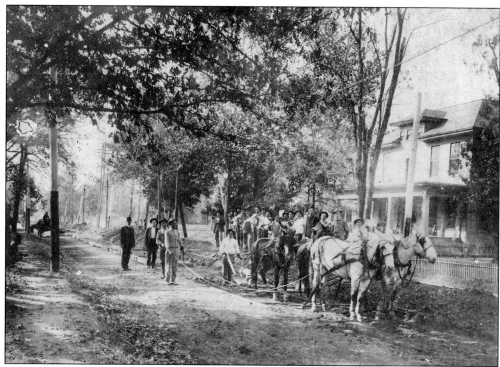

In 1913, Tyler Traction Company operated a trolley line. Their motto was "anywhere for a nickel." With about 7 miles of track, it had up to eight cars operating at the same time. Unfortunately the line fell on economic hard times and ceased operations in 1917. The photograph above shows the placement of the first mile of track on North Bois D'Arc Avenue. The man with the open coat in the middle of the street, just beyond the work crew, is Tom Smith, the construction foreman, with R. B. Haynes, city street superintendent, to the left of him. The photograph below shows a streetcar on North Bois D'Arc Avenue covered with a banner advertising a Presbyterian Sunday school picnic. The buildings in the background belong to First Baptist Church. (Both courtesy of the Smith County Historical Society.)

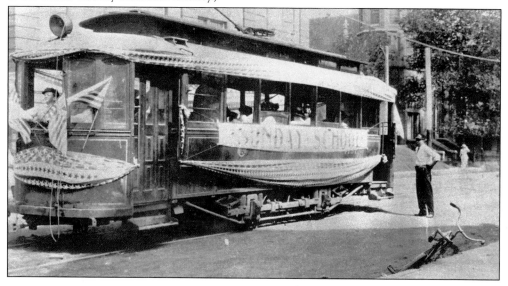

This 1911 photograph shows Orelia Albertson Blackburn on the front lawn of her house with her daughters, left to right, Mary Octa, Imogene, and Margaret. In the back seat of the surrey are Ellen Albertson (left) and Hattie Albertson, while in the front seat are Fannie Albertson (left) and Annie Albertson. The surrey, pulled by Charlie the horse, is decorated for a parade. (Courtesy of the Smith County Historical Society.)

Bergfeld Park was created in 1913 on land donated to the city by Rudolph Bergfeld. The small lake shown was originally in the center of the park. Because Tyler's Sears store was the only one in the chain to make a profit during the Great Depression, company president R. E. Wood donated money in 1936 to build the park's amphitheater, which replaced the lake. (Author's collection.)

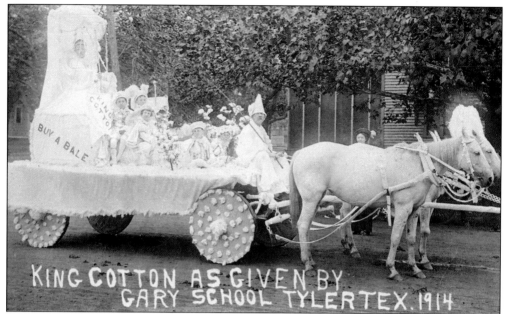

By the 1890s, cotton was Tyler's biggest commodity, with the city having become its major East Texas market. Cotton farmers became so productive that their yields created surplus and depressed prices. In the 1930s, the Agricultural Adjustment Administration eliminated surplus by paying farmers to plant legume or feed crops. Many never returned to cotton. Shown is Gary Elementary School's entry in a 1914 parade. (Courtesy of the Smith County Historical Society.)

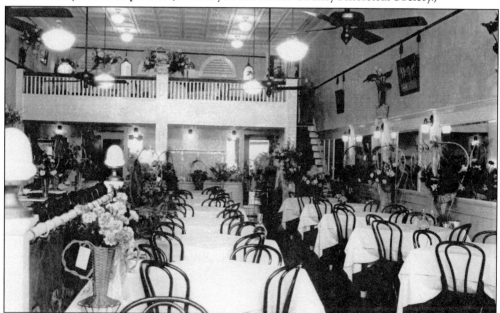

William, Constantine, and Joseph Haddad, three immigrant brothers from Lebanon, opened the Mecca Café at 110 East Ferguson Street on September 30, 1915. A fire destroyed the interior in October 1927, but the brothers rebuilt, added a balcony, and reopened in January 1928. William died in 1939, and the remaining brothers went into other businesses. Harry Sobol operated the restaurant until the mid-1940s. (Courtesy of the Smith County Historical Society.)

Presbyterians started meeting in April 1870 at the Methodist Church in Tyler. By around 1910, three Presbyterian churches were active. Their leaders met and decided to unite, using the name First Presbyterian Church. Rev. Robert Hill served as pastor from 1915 to 1946. Their church was located on the southwest corner of South Broadway Avenue and West Elm Street. (Courtesy of the Smith County Historical Society.)

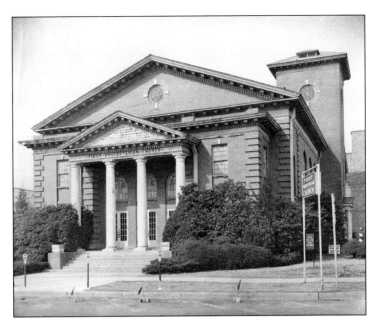

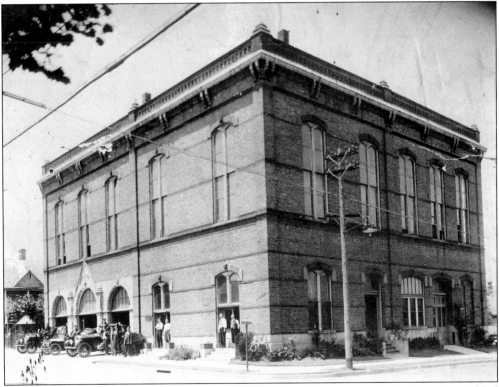

The 1886 Locust Street Fire Station is shown in 1916 with additional garage entrances added for the first motorized equipment. Cages can be seen in the empty lot just beyond the fire engines to the left. These cages comprised the first Tyler zoo, which was maintained by the firemen and included such animals as monkeys and alligators. (Courtesy of the Smith County Historical Society.)

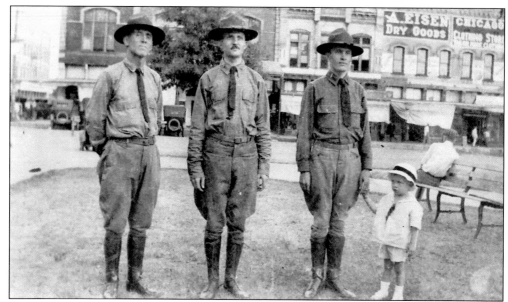

Shown on the courthouse square are three members of Tyler's home guard. Formed for patriotic purposes, the guard had 60 members by mid-June 1917 and drilled two nights a week. After requesting and receiving uniforms from the War Department, the invigorated group drilled every evening. The War Department never did supply requested arms. (Courtesy of the Smith County Historical Society.)

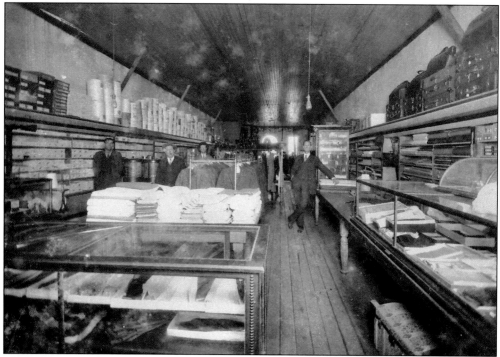

The Caldwell, Hughes, DeLay, and Allen department store was located on the west side of the square at 108 North College Avenue. C. M. Pope Sr. is shown to the far right in this photograph taken on January 1, 1918. (Courtesy of the Smith County Historical Society.)

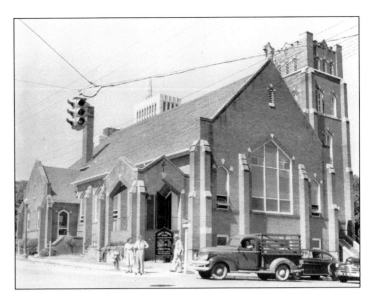

Emir Hamvasy was a Hungarian who once was minister of finance and mayor of Budapest. After participating in a failed revolution, he came to the United States and studied for the ministry. He arrived in Tyler in 1872 as the first rector of Christ Episcopal Church. Located on the northeast corner of South Bois D'Arc Avenue and West Elm Street, the church shown held its first services in 1918. (Courtesy of the Smith County Historical Society.)

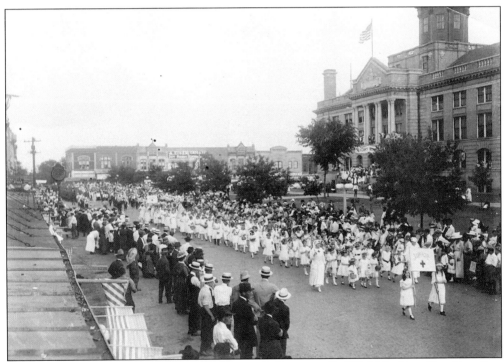

On June 14, 1919, members of the Smith County's Company C, 133rd Machine Gun Battalion returned from World War I and were welcomed home with a parade around the courthouse square. The Junior Red Cross is shown, followed by the soldiers. They circled the square several times, while aircraft flew overhead dropping flowers on the men. A large barbecue banquet followed on the east side of the square. (Courtesy of the Smith County Historical Society.)

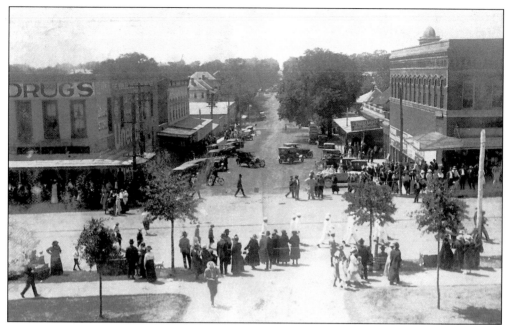

This is a view looking south down Broadway Avenue from the 1910 county courthouse. Clark's Drug Store is on the left corner, and the old East Texas Conservatory of Music Building is on the right, with the top of First Presbyterian Church just barely visible above the building. Erwin Street is roped off, probably for a parade. (Courtesy of the Smith County Historical Society.)

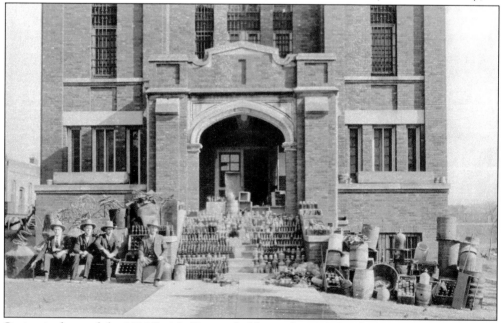

Sitting in front of the 1916 Smith County Jail located at 110 South Spring Street, members of the Smith County Sheriff's Department are surrounded by confiscated stills and bottles of moonshine. The gentlemen in this 1920s photograph are, from left to right, Sheriff Will Strange, office deputy Ed Holt, Deputy John Gregory, and chief deputy L. T. Godfrey. (Courtesy of the Smith County Historical Society.)

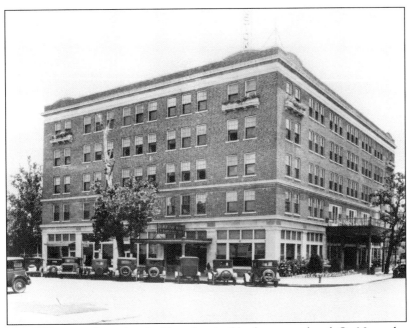

The Tyler Hotel Company formed and sold stock to build a downtown hotel. On November 29, 1922, the Blackstone Hotel opened on the northeast corner of North Broadway Avenue and East Locust Street. The hotel, shown in the above photograph, was a five-story, $500,000 structure, originally leased to R. E. Pellow, a Waco hotel proprietor who spent $65,000 to furnish his new property. The grand-opening formal dinner in the Blackstone's Ballroom is shown below. The hotel was successful, with no peers to its quality of service. A nine-story tower on the north side added 64 rooms. In 1939, the hotel was air-conditioned, and the Blackstone office building was constructed immediately north of the hotel. (Both courtesy of the Smith County Historical Society.)

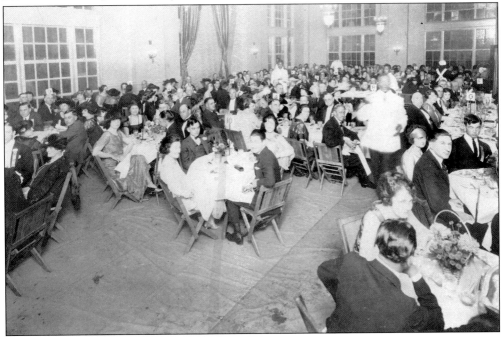

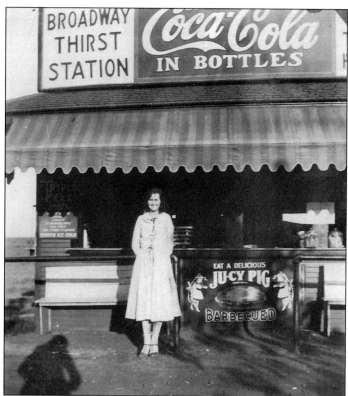

In the early 1900s, the Galveston Brewing Company began to sell a line of soft drinks under the Triple XXX trademark to licensed bottlers, soda fountains, and thirst stations. Located at 1703 South Broadway Avenue, the Broadway Thirst Station was a busy place in the 1920s and 1930s. In the photograph is Bonnie Hollingsworth, perhaps about to wash down a "barbecued ju-cy pig" with the popular root beer. (Courtesy of Gail Clark.)

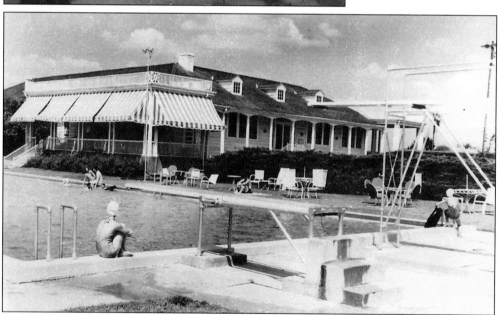

In 1921, a charter was signed for "a club for golf, tennis and other innocent sports." Originally to be called Dixie Highway Country Club, the final name was Willow Brook Country Club, which is located at 3205 West Erwin Street. The original clubhouse, shown in the photograph, opened in June 1923 and was replaced in October 1962. The swimming pool shown was added in 1935. (Courtesy of the Smith County Historical Society.)

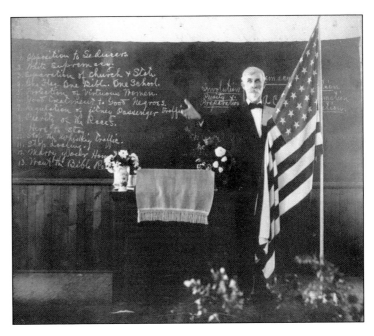

Born in 1857, Rev. Albert Sidney Poindexter was pastor of Grace Baptist Church. The view shows him giving a sermon on May 21, 1922, with rather unexpected points on the blackboard. In the 1920s, he owned a printing company that published a Ku Klux Klan newspaper called *Tyler American*. After he died in 1924, Klansmen performed funeral rituals in full costume by his graveside in Rose Hill Cemetery. (Courtesy of the Smith County Historical Society.)

Chartered on January 19, 1849, St. John's Masonic Lodge No. 53 is one of the oldest lodges in Texas. At one point in its early days, the lodge shared a building with Marvin Methodist Church. The lodge shown in this photograph was built in 1923 at 323 West Front Street. Tyler Lodge No. 1233, chartered December 2, 1925, spun off from St. John's. (Author's collection.)

Tyler Little Theatre was formed in 1927, with performances held at Tyler High School and the Woman's Building auditorium. Its own venue was built in 1939 on the southeast corner of South Glenwood Boulevard and West Houston Street. During World War II, productions were stopped, and the building was sold. In 1949, the theatre was reborn as Tyler Civic Theatre, and it opened what was reportedly the nation's first theatre-in-the-round in 1951, shown here. (Courtesy of the Tyler Civic Theatre Center.)

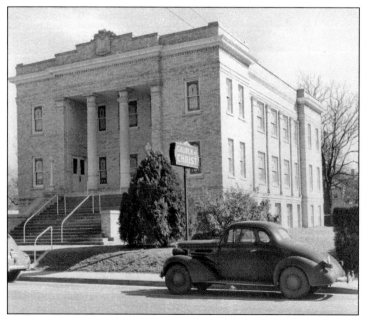

Originally called the Tyler Church of Christ, the West Erwin Church of Christ formed in 1885 and for a number of years met in a tent. The photograph above shows their first brick church, dedicated in November 1927. This building was demolished to make way for a new education wing after a new auditorium was constructed in 1955 at 420 West Erwin Street. (Courtesy of the Smith County Historical Society.)

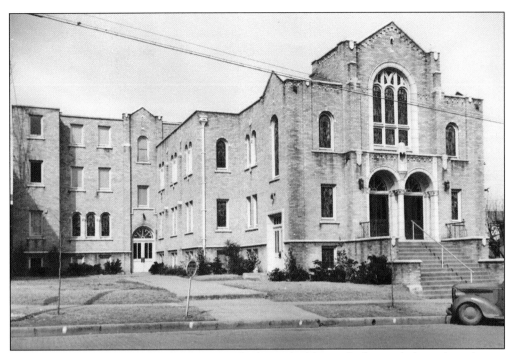

First Christian Church's growth necessitated a larger building, which was dedicated on August 19, 1928. Located on the southwest corner of South Broadway Avenue and University Place, this building appears here. This site remained the church's home until 1965, when it relocated to 4202 South Broadway. (Courtesy of the Smith County Historical Society.)

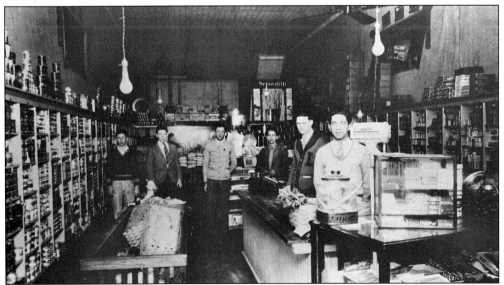

Wood T. Brookshire and several brothers operated grocery stores under the name Brookshire Brothers. On September 1, 1928, they opened their first self-serve store in Tyler at 113 North Spring Street. The interior is shown, which only measured 25 feet wide by 100 feet deep. The brothers' partnership dissolved in 1939, with Wood becoming sole owner of the three Tyler stores. (Courtesy of the Brookshire's Grocery Company.)

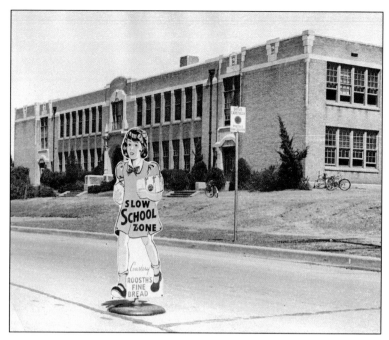

Located at 920 South Broadway Avenue, Hogg Junior High School opened in 1929. Its namesake, James S. Hogg, was the first native-born Texas governor. He lived and practiced law in Tyler and was a good friend of Horace Chilton. This 1930s photograph includes the school with a crosswalk sign "Courtesy Roosth's Fine Bread." (Courtesy of the Smith County Historical Society.)

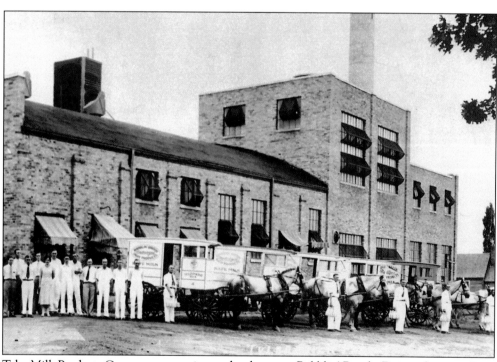

Tyler Milk Products Company, operating under the name Babblin' Brooks Dairies, began in June 1929. Located at 805 West Front Street, this was Tyler's first milk-processing plant. Local dairy farmers would drop off fresh milk before dawn, and it would be processed and ready for delivery by 10:00 a.m. The company dissolved in October 1943, with the plant and equipment being sold to the Borden Company. (Courtesy of Gail Clark.)

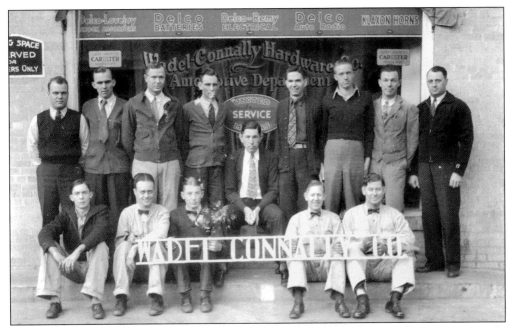

Opened in 1930, the Wadel-Connally Company was a wholesale hardware and automotive-supply company located at 412 North Spring Street, with an accessory department at 112 East Line Street and a repair department at 312 North Spring Street. The company was successful, with the 1960 City Directory showing branch stores in 14 other Texas cities, including San Antonio and Orange. (Courtesy of the Smith County Historical Society.)

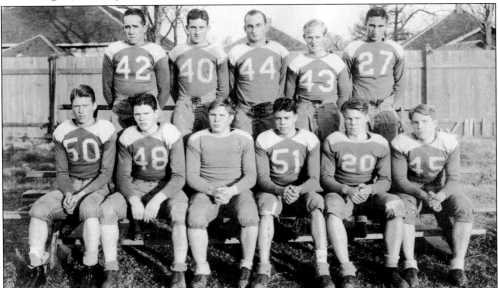

In 1930, the Tyler High School football team won the first district and state championships, in any sport, for Tyler. Pictured from left to right are (seated) Neal Harville, Thomas Glass, Leland Wilcox, Arthur Johnson, Davis Wilcox, and John Wilcox; (standing) Albert Hill, Harry Johnson, Clifford Gregory, John S. Morris, and Reagon Gregory. Coach George Foltz later led the Tyler Junior College team to the Texas Junior College Athletic Association basketball championship during the 1932–1933 season. (Courtesy of the Smith County Historical Society.)

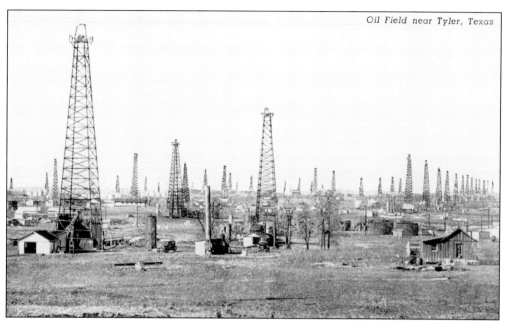

Oil Field near Tyler, Texas

In the 1930s, the East Texas Oilfield, the largest in the world at the time, was discovered in Tyler's backyard. It was the largest metropolitan city in the area, so Tyler attracted the most people and new business. Hotels and boardinghouses were full, more office space and residences were built, and stores and restaurants had great business. The local oil industry eventually waned, but its timing saved Tyler from the worst of the Great Depression. (Author's collection.)

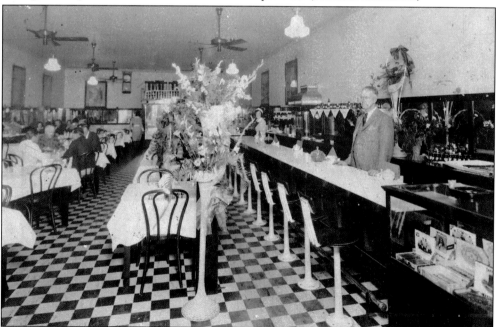

Located at 106 East Ferguson Street, Ashby's Café was owned by Claude D. Ashby, shown behind the counter to the far right in this c. 1931 photograph. His business interests were soon to change, for the 1932 City Directory no longer listed the café and gave Claude's occupation as an oil operator. (Courtesy of the Smith County Historical Society.)

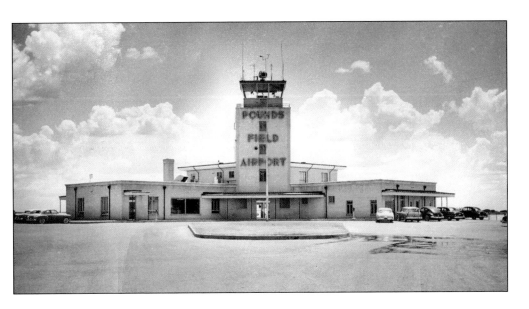

O. C. Palmer, an Army Air Corps pilot during World War I, was picked by the city commission in 1929 to head a committee to develop an airport. He soon was named the first airport manager, a job he performed until the late 1940s. The city purchased 296 acres on the west side of Dixie Drive, and in 1930 the airport opened with two runways. In 1934, the airport was renamed Rhodes Field in honor of chamber of commerce manager Russell Rhodes, and the first air-mail flight occurred on September 1 of the same year. During World War II, the airport was renamed Pounds Field. The above image shows the airport terminal, which opened in 1949. Various airlines have serviced the airport since 1934, including Delta, Braniff International, and Texas International. (Both courtesy of the Smith County Historical Society.)

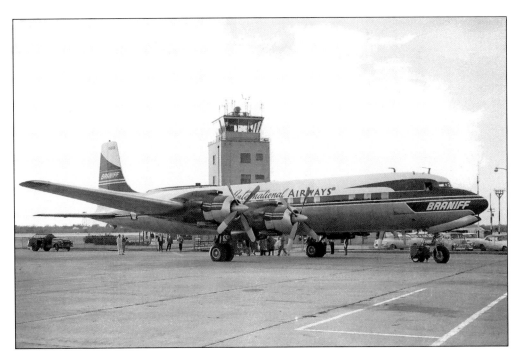

The Woman's Forum organized in 1923 when several literary clubs merged. It had a plan to build a municipal auditorium for civic, social, and educational programs. Judge Samuel Lindsey donated the land for the structure in 1931. The Woman's Building, located at 911 South Broadway Avenue, was completed in June 1932. It formally opened on October 4, 1932, with a performance by Tyler Municipal Band. (Author's collection.)

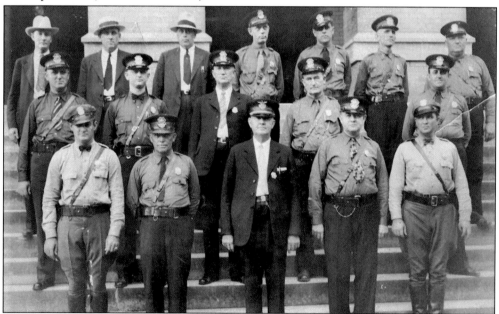

This c. 1932 view shows Tyler Police Department members on the steps of the county courthouse, where they were housed on the first floor. Pictured from left to right are (first row) John Kilpatrick, Madison Lewis, Chief Jefferson Ray, Walter Rice, and Clyde Bentley; (second row) Kames Gabriel, Roy Lively, night chief John Messer, Phonso Rayford, and Duncan Butler; (third row) H. Cliff Hudson, Jim Adams, Coy Ramsour, Euris Wade, Joe Elliott, Jess Rayford, and Karl Veasey. (Courtesy of the Tyler Police Department.)

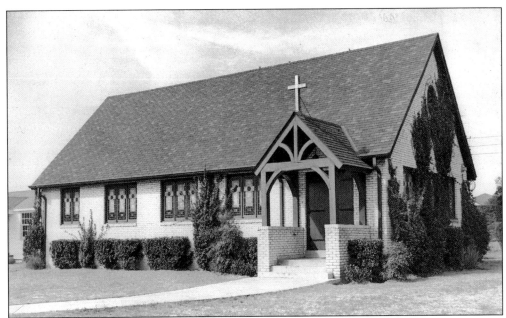

Trinity Lutheran Church officially organized in September 1932. The congregation originally met in the auditorium of the Carnegie Public Library from May 1932 to April 1942. A chapel located on the southwest corner of South Robertson Avenue and Lindsey Lane was dedicated on April 26, 1942, and is shown in the views. A parsonage was purchased, adjoining the chapel at 1013 South Robertson. An education building was completed in 1948 utilizing a surplus building moved from the closed Camp Fannin. It was quickly outgrown, and a new educational building was built and dedicated on September 29, 1957. A new church located at 2001 Hunter Street was dedicated on October 7, 1973. (Both courtesy of Trinity Lutheran Church.)

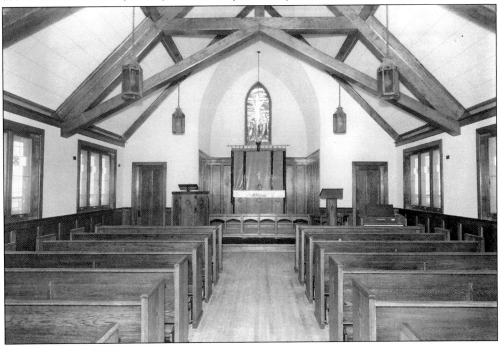

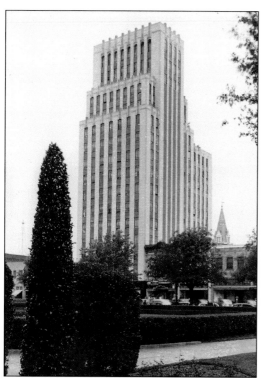

Founded in 1892, Peoples National Bank is shown here on the northwest corner of North College Avenue and West Erwin Street. Opened in November 1932, it was reportedly the largest private construction project in the nation during the Great Depression. A 10-story annex was added in 1936. The drive-up window added in 1949 and escalators added in the 1950s were the first ones in the area. (Author's collection.)

The last reunion of Tyler Confederate soldiers was held at the Woman's Building at 911 South Broadway Avenue in 1933. These gentlemen from left to right are (seated) D. R. Holland, Pinkney Clancy, George E. Miller, A. J. Zorn, Benjamin F. Ware, and H. J. Rix; (standing) W. W. Queen, J. S. Duncan, James T. Clinkscales, Horace H. Rowland, Asberry C. Braziel, and W. S. Cole. (Courtesy of the Smith County Historical Society.)

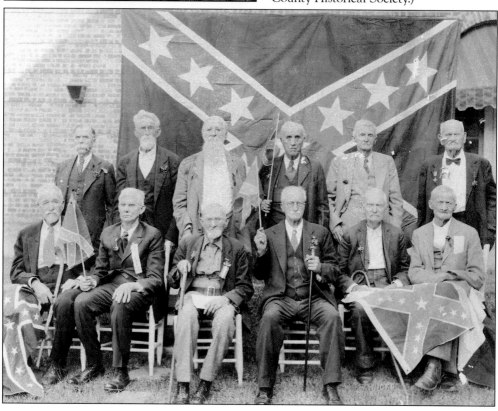

Along with fruit trees, Matthew Shamburger was selling rose bushes in the mid-1800s. Others in the area soon began growing roses as well, for the conditions were ideal for the plant. A major peach blight killed most area peach trees shortly after the turn of the 20th century, and many of those growers switched to roses. In 1917, Bonnie Shamburger, grandson of Matthew, was the first to ship rose bushes via train far outside of Texas. By the mid-1920s, the local rose industry was expanding rapidly. Over the years, reports estimated that at times from one-third to one-half of the rose bushes produced in the United States were from the Tyler area, which made the city recognized as the "Rose Capital of America." Both of these views show rosebush harvesting in the 1930s. (Both courtesy of the Smith County Historical Society.)

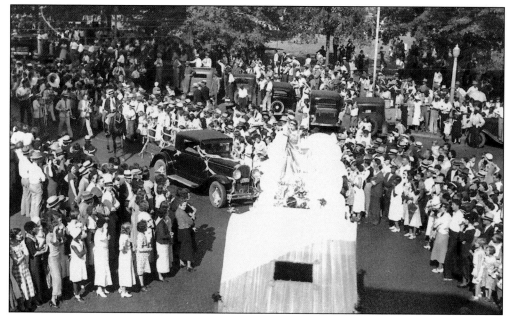

In August 1933, Tyler Garden Club members convinced chamber of commerce manager Russell Rhodes to hold an annual East Texas Rose Festival to promote the local industry. Held on October 11–12, 1933, the first event's theme was "Festival Fairyland" and featured a Rose Show, a downtown Rose Parade, and a Queen's Coronation held in Bergfeld Park. Margaret Copeland from nearby Palestine was announced the Rose Queen at the coronation, selected from princesses who came from nearby towns. Afterward, local residents complained that the queen was not from Smith County, so organizers agreed that from then on the queen would be from Tyler. Shown above is a parade float turning off West Erwin Street onto South Broadway Avenue, and below is a festival advertisement on a car's tire cover. (Both courtesy of the Smith County Historical Society.)

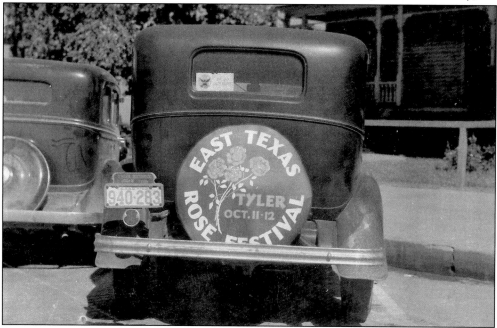

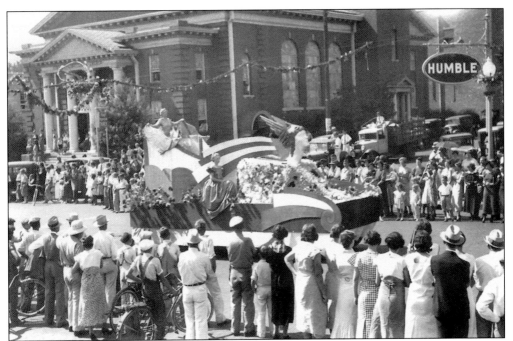

In 1934, the East Texas Rose Festival Association was chartered to organize future annual Rose Festival events. That same year, the second festival was held and was more successful than the first. Louise Boren served as Rose Queen, and the festival theme was "A Garden in Venice." Local attorney Thomas B. Ramey served as association president again. These two views are of the 1934 Rose Parade, taken as the floats traveled north on South Broadway Avenue, crossing Elm Street, with First Presbyterian Church in the background. Starting with the 1935 Rose Festival, a collegiate football game was added to the activities, which continued through the 1941 festival. (Both courtesy of the Smith County Historical Society.)

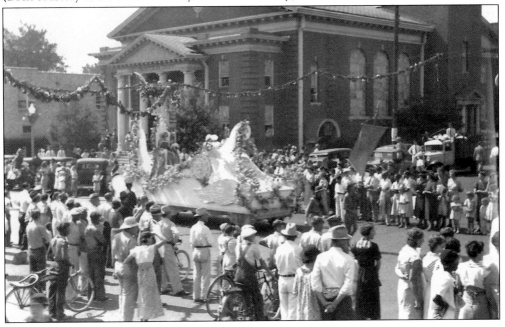

The 1886 Federal Building was demolished in 1933 to make way for a larger building with the same function. The above view is looking southwest over the construction site, with the background including First Baptist Church to the right and the steeple of Marvin Methodist Church in the far center. The new building, known as the U.S. Post Office and Courthouse, is shown in the view below after its dedication on August 4, 1934. The main post office remained here until it relocated to new facilities at 2100 West Martin Luther King Jr. Boulevard, dedicated in 1981. (Both courtesy of the Smith County Historical Society.)

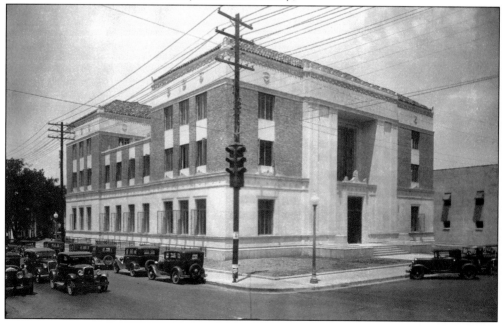

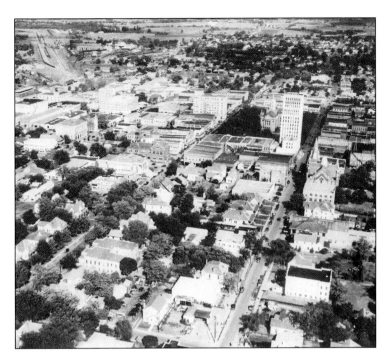

This aerial photograph was most likely taken in early 1933. Peoples National Bank was just completed, and the 1886 Federal Building was soon to be demolished. The 1910 county courthouse sits in the middle of downtown, and in the upper left corner the Cotton Belt Railroad yards and shops can be seen. The skyline would change so much during the remainder of the 20th century. (Courtesy of the Smith County Historical Society.)

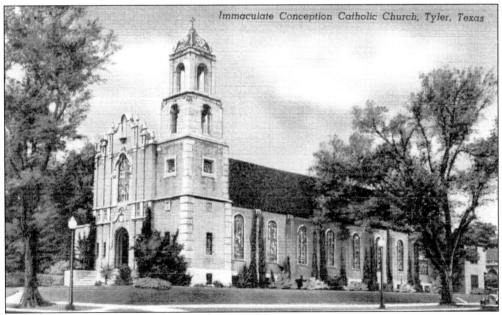

By 1919, Immaculate Conception Catholic Church began saving money for a new building. Construction began in 1934 on the southwest corner of South Broadway Avenue and West Front Street. Though the interior was not yet completed, the parish moved in by Christmas of that same year, with the actual dedication on March 17, 1935. (Author's collection.)

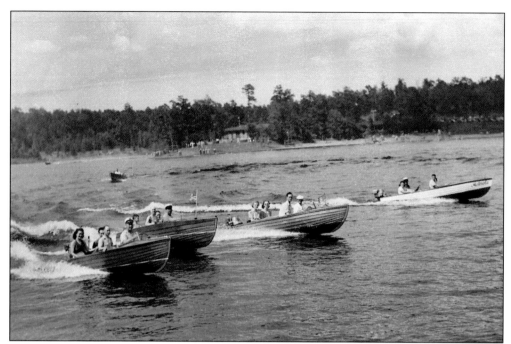

Located about seven miles north of the city, Tyler State Park encompasses 985.5 acres of land deeded by private owners in 1934 and 1935. The original improvements were made by the Civilian Conservation Corps, the first New Deal program started by Pres. Franklin D. Roosevelt. Fifteen work camps, containing a total of 2,620 men, were established across Texas to concentrate on state park improvements as part of this program. Tyler State Park opened in 1939, with its spring-fed, 64-acre lake as the centerpiece. Besides the activities shown in these photographs, others include fishing, hiking, and camping. (Both courtesy of the Smith County Historical Society.)

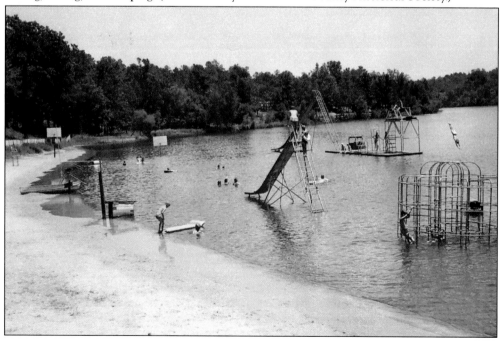

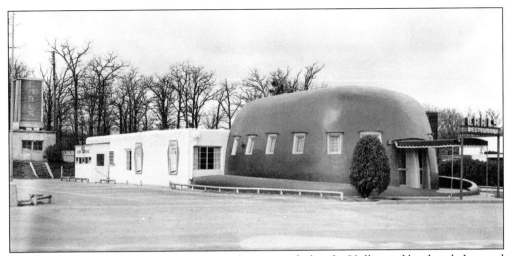

The Brown Derby Drive-In Café was obviously patterned after the Hollywood landmark. Located at 1905 South Broadway Avenue, it opened in December 1935, offering inside dining or carhop service, as well as a red carpet at the entrance and a jukebox at each table. The restaurant closed in 1953 and served as a used-car lot for Claude Holley before being demolished around 1958. (Courtesy of the Smith County Historical Society.)

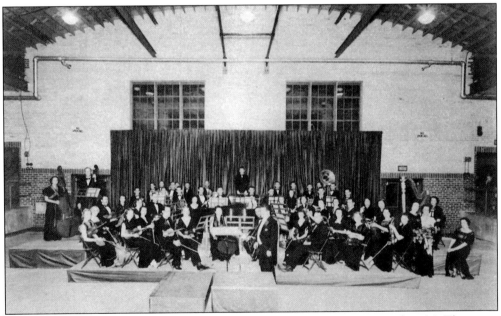

Tyler Symphony Orchestra began performing four-concert seasons in March 1936. The group disbanded during World War II, but community leaders revived the orchestra in 1950. Children's concerts were started in 1951 for elementary students of area public and parochial schools. In 1954, the group was renamed East Texas Symphony Orchestra to better represent the area from where the musicians and their audience came. (Courtesy of the Smith County Historical Society.)

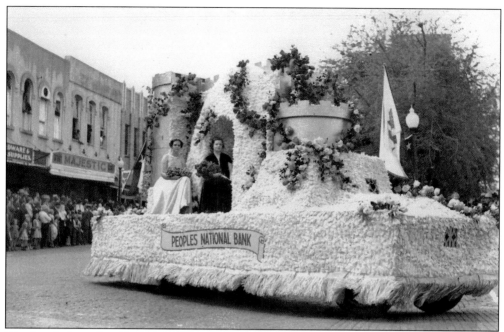

The fourth festival in 1936 gave the event a new official name: Texas Rose Festival. For the fifth annual festival, the Rose Queen was Katherine Booty and the theme "Flowers of the World." These two views are of the Rose Parade held October 9, 1937, taken as the floats turned off East Erwin Street onto North Spring Avenue. Shown above is the float sponsored by Peoples National Bank, which is just barely visible behind the tree in the background. Below is the float sponsored by local beer distributor P. A. Peters' Falstaff Sales Company. This type of sponsorship was not unusual, for 3.2 percent beer sales were legal in Tyler from 1933 to 1939. (Both courtesy of the Smith County Historical Society.)

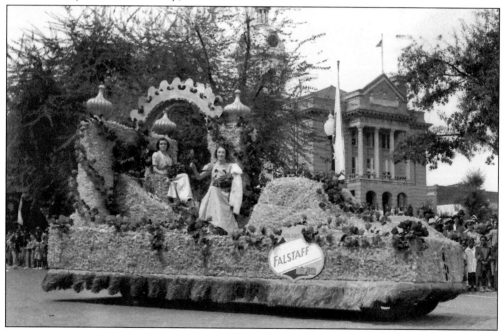

Born in Corpus Christi, Dr. Eldon Wood Lyle, shown here, came to Tyler in 1937, where he began his career as a pioneer in field-grown rose research. The Texas Rose Research Foundation was created in 1946 by growers, and Eldon headed the organization for decades. Shown below, local car dealership owner Claude Holley (second from left) is handing keys to Eldon for a truck donated to the foundation. Eldon's expertise brought international recognition, and he received the Gold Honor Award from the American Rose Society in 1965 for his research that improved many aspects of the industry. His disease research is credited with preventing the same tragedy to the local rose growers that wiped out the peach growers years before. (Both author's collection.)

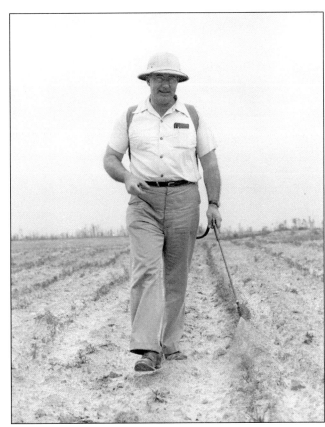

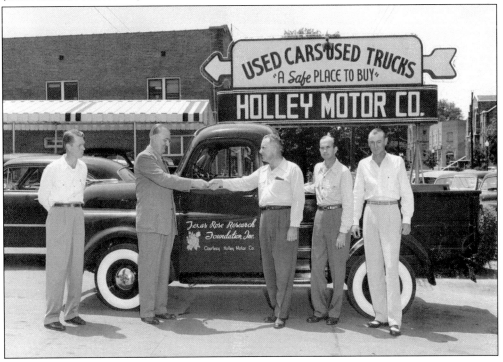

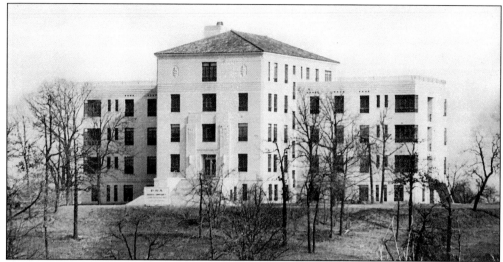

When the Public Works Administration made funds available for public projects, Tyler became the first city to receive funds for a hospital. The Sisters of the Holy Family of Nazareth made the best offer to manage the hospital, and they were given the lease. The hospital was named in honor of Frances Siedliska, founder of their order, and the Sisters later exercised an option in their lease and purchased it. The grand opening was scheduled for March 19, 1937, but the hospital was pressed into service a day early when a gas explosion at the New London Consolidated School injured and killed hundreds of students and teachers. The above view shows the hospital as it originally looked in 1937. The view below shows it after additions in 1948 and the 1960s. (Both courtesy of the Smith County Historical Society.)

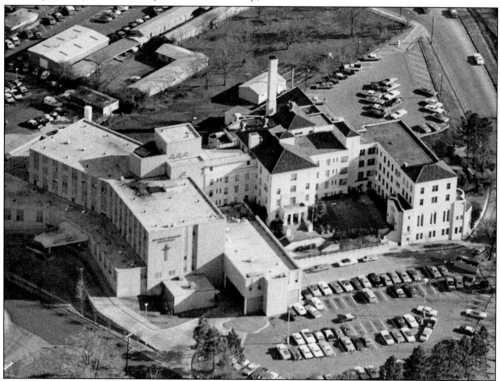

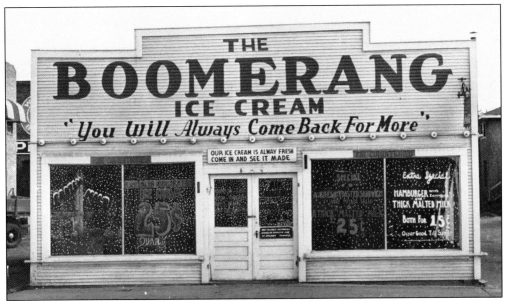

The Boomerang opened in 1937 at 822 West Erwin Street. Owned by Arthur Exum, the establishment became popular not only for its ice cream, but also its hamburgers and jukebox. Business waned during the war years, and it closed around 1945. (Courtesy of the Smith County Historical Society.)

Shown is John Franklin Witt directing the Tyler High School Band on November 25, 1937. Witt, better known as "Doc," came to Tyler in 1908 to direct the Tyler Kid Band, which later became the Tyler Municipal Band. In 1921, he organized the Tyler High School Band. He left in 1947 to organize the Tyler Junior College Band, where he remained until his 1952 death. (Courtesy of the Smith County Historical Society.)

David King Caldwell, known simply as "D. K.," came to Tyler in 1919 as a road engineer. After gaining financial security through investments, he and wife Lottie were devoted to many interests. One was the Caldwell Play School, shown above, which was started in his backyard at 421 South Bonner Avenue. The man is D. K., while the women are Betty Gorman (left) and Irene Pirtle. In 1937, D. K. started a small backyard zoo for the playschool that included, among other species, monkeys, peacocks, and an alligator. When the zoo grew too large, he bought a farm in 1953 to relocate it, giving it the name Caldwell Children's Zoo, shown below. Still located at 2203 West Martin Luther King Jr. Boulevard, today it is simply called Caldwell Zoo. (Above, courtesy of the Smith County Historical Society; below, courtesy of the Caldwell Zoo.)

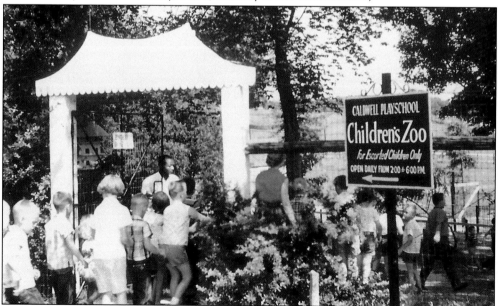

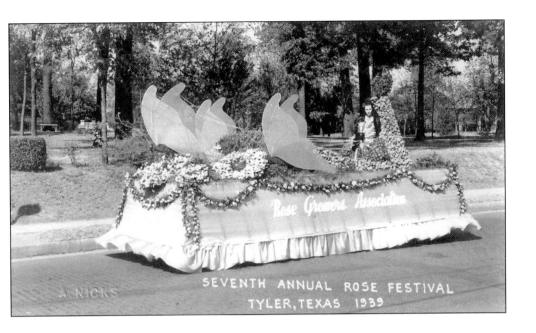

The 1938 festival theme was "Southern Plantations," while the Rose Queen was Frances Connally. At the queen's coronation in Bergfeld Park, portable bleachers collapsed, injuring 35 spectators, some of whom suffered broken backs and legs. In 1939, a group called the Strutters was formed to coordinate the parades. These two postcard views are of 1939 parade floats. A float sponsored by the Rose Growers Association is shown above, while Rose Queen Dorothy Bell is seen on her float below. (Both courtesy of the Tyler Public Library.)

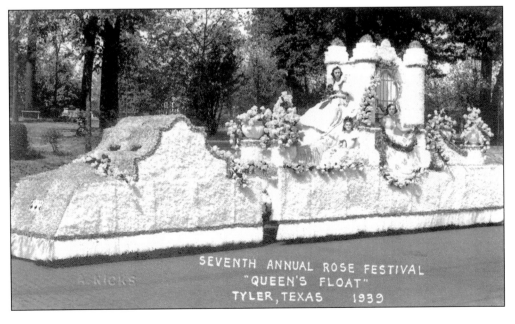

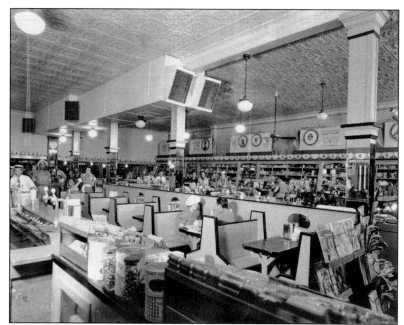

In the mid-1930s, U. R. Neil and Jack Simpson opened their Neil-Simpson Drugs store at 218 North Broadway Avenue, shown above. The wide variety of merchandise offered and the popularity of the lunch counter led to a chain of 11 locations, 7 in Tyler and 4 in Lufkin, with a warehouse on Highway 271. Shown below is the October 1938 grand opening of Neil-Simpson Drugs second location at 314 West Rusk Street, with a live band in the right background. In 1954, U. R. Neil retired and sold his share of the business, and in a few years Jack Simpson sold his share as well. In 1970, two of the Tyler locations, including the original one on North Broadway Avenue, were closed, and the others were turned into Ward Cut-Rate Drug stores. (Both courtesy of the Smith County Historical Society.)

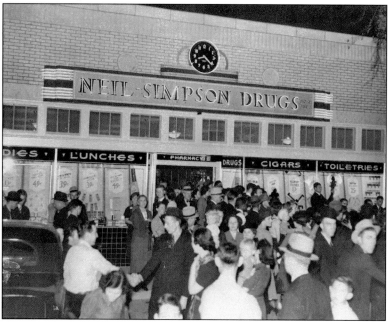

As was the norm in drugstores during that time, the Neil-Simpson Drug Store No. 2, located at 314 West Rusk Street, had a soda fountain. This was the busy scene during opening night on October 27, 1938. (Courtesy of the Smith County Historical Society.)

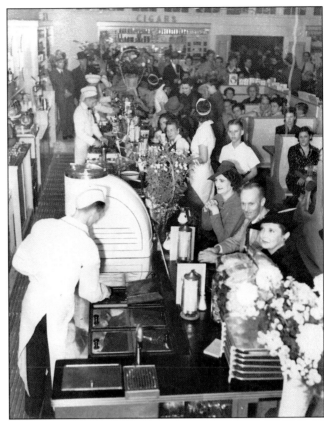

This c. 1937 view is of the M System Grocery Store No. 2, located at 727 North Bois D'Arc Avenue. Pictured from left to right are unidentified, unidentified, Marvin Hariott, Melvin Crawford, J. L. Reynolds, and Jewell Mauldin. J. L. Reynolds was the son of the owner, who also had eight additional M System stores. Jewell was the manager and later worked for the Brookshire's Grocery Company. (Courtesy of the Smith County Historical Society.)

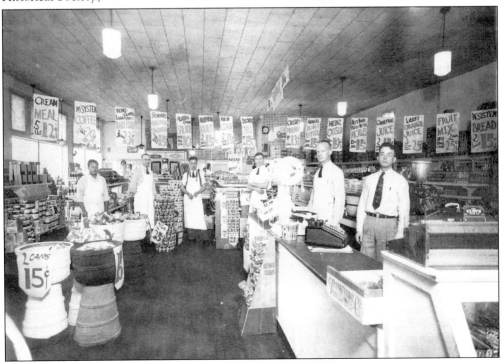

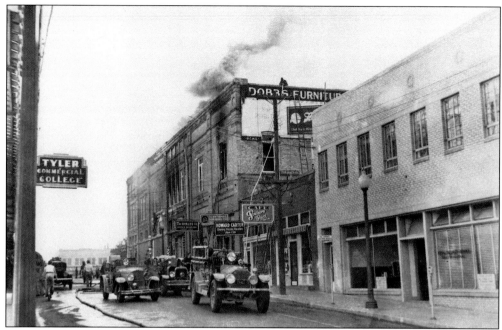

The Elk's Club, which occupied the second floor on southeast corner of South College Avenue and West Erwin Street, suffered an early morning blaze on June 27, 1939. Businesses on the first floor also suffered damage from the fire, which started near a steam-vapor bath booth in the club. (Courtesy of the Smith County Historical Society.)

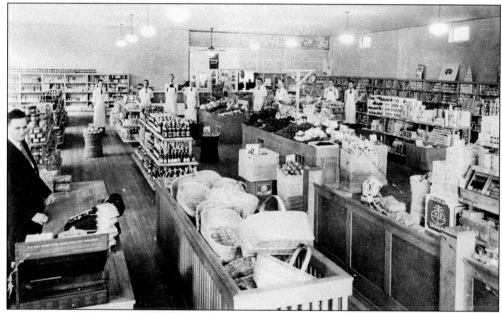

The Brookshire's grocery store on the northwest corner of South Broadway Avenue and West Front Street was reportedly the first air-conditioned grocery store in East Texas. The store is shown c. 1939, with Wood T. Brookshire appearing to the far left. Over the years, Brookshire's Grocery Company continued to grow. It opened its first warehouse in Tyler in 1953. (Courtesy of the Brookshire's Grocery Company.)

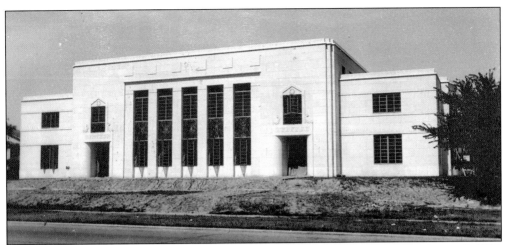

Located at 212 North Bonner Avenue, the $125,000 city hall building opened on August 3, 1939. Its construction was a project of the Works Progress Administration, Pres. Franklin Roosevelt's New Deal program that also constructed Mother Francis Hospital and heightened the dam on Lake Bellwood. This photograph of city hall was taken as construction was nearing completion. (Courtesy of the Smith County Historical Society.)

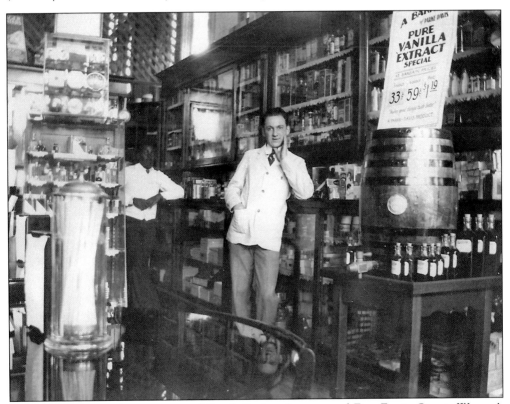

Located on the southeast corner of South Spring Avenue and East Erwin Street, Warren's Pharmacy offered "fast, free motorcycle delivery." The 1930s photograph shows Thomas Tomlin (right) and another unidentified employee. Thomas performed a wide range of duties, from soda jerk to bookkeeper. (Courtesy of Tommy Tomlin.)

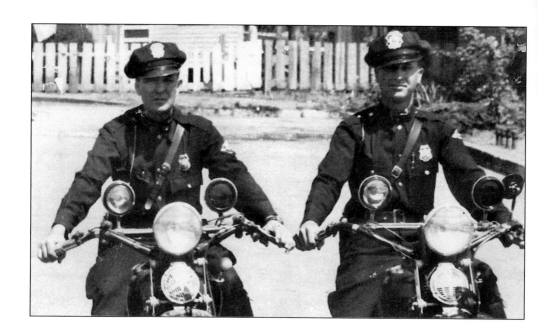

These late 1930s photographs show Tyler Police Department motorcycle officers. The above view includes Clyde Bentley (left) and Hoke Vickery, while seen below is John Percy "Rosie" Kilpatrick atop his Harley Davidson with the courthouse in the far background. Clyde and Rosie were the first motorcycle policemen hired by the department. During this time, the officers had to furnish their own boots and motorcycle. (Both courtesy of the Tyler Police Department.)

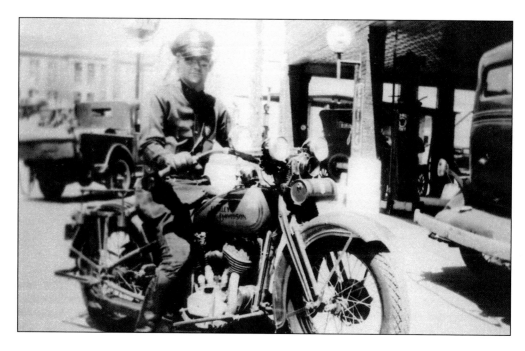

Four
1940s THROUGH 1960s

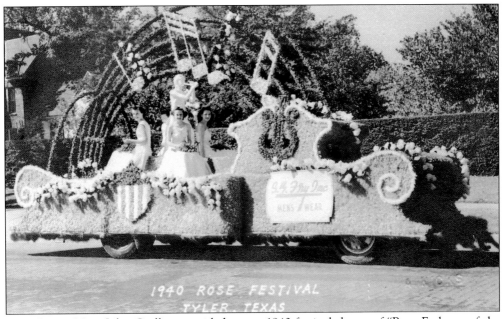

Rose Queen Mary John Grelling presided over a 1940 festival theme of "Rose Embassy of the Muses." Starting this year, the Queen's Coronation was moved from Bergfeld Park to Tyler High School Auditorium. After the ninth festival in 1941, the event was suspended due to World War II. (Author's collection.)

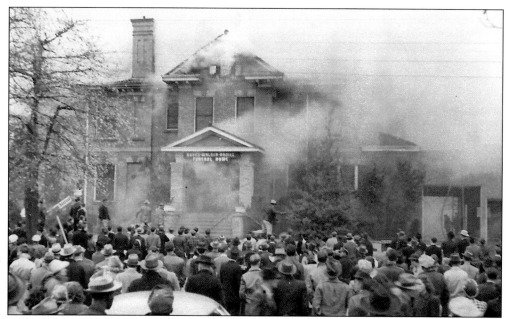

Organized by James Walker, Henry Burks, and Judge T. B. Butler, the Burks-Walker Funeral Home traces its history back to 1905 when it was located at 400 West Erwin Street. They also offered ambulance service and operated the Burks-Walker Furniture Company located at 214 North Broadway Avenue. Around 1936, the funeral home relocated to 215 East Front Street, property that was purchased from the A. P. Moore family. J. F. Daniel became part owner in 1938. On February 2, 1940, the interior of the structure was gutted by fire, as shown in the above photograph. The building was completely remodeled, as shown in the below c. 1950s view. R. L. Tippit purchased Daniel's share of the business in 1941. In 1971, Harold Jackson became part owner, but over the next years became sole owner of Jackson's Burks-Walker-Tippit Funeral Directors. (Both courtesy of the Smith County Historical Society.)

The 1940s photograph at right shows two contestants in a Miss Tyler Pageant being held at Fun Forest Park. Contestants were sponsored by local businesses, with the winner moving on to represent the city at the next pageant level. Jo-Carroll Dennison, who at the time was a self-supported student in Tyler's Federal Institute, was talked into being Miss Citizen's National Bank in the pageant in 1942, only because she would receive a free bathing suit. She won Miss Tyler and went on to win Miss East Texas, Miss Texas, and finally Miss America—the first Miss Texas to do so. As the first wartime Miss America, Jo-Carroll, shown below, sold thousands of dollars of war bonds. After her reign, she had a career in movies and television. (Right, author's collection; below, courtesy of Randy E. Pruett/Miss Texas Organization.)

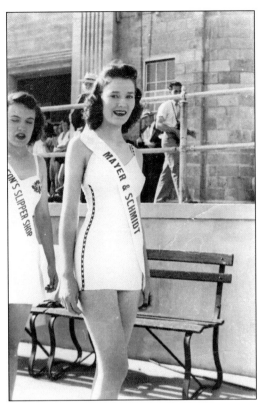

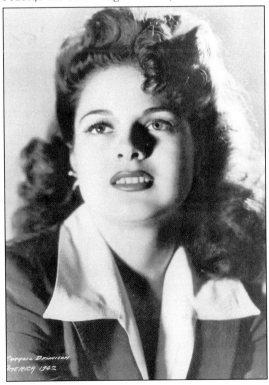

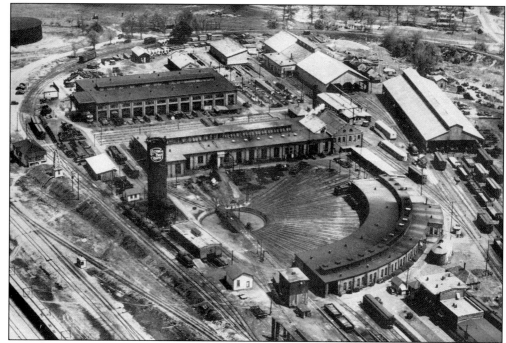

The 1941 aerial photograph above shows the St. Louis Southwestern Railway shops, located just northeast of downtown Tyler. The long shed structure in the upper right corner opened in May 1898. Visible also is the black Cotton Belt Route water tower rising just to the left of the turntable for the crescent-shaped roundhouse. An interior view of the roundhouse in October 1956 is shown below. (Above, courtesy of the Smith County Historical Society; below, courtesy of the Tyler Tap Chapter of the Cotton Belt Rail Historical Society.)

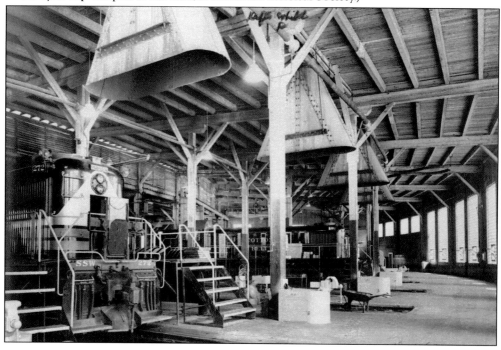

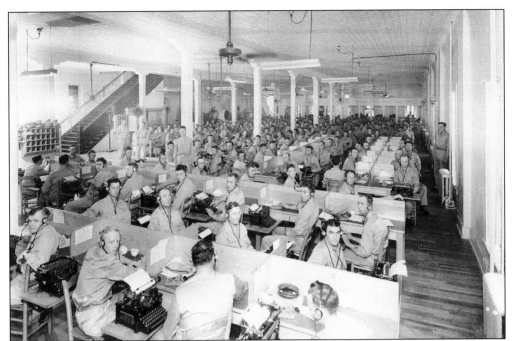

Even before construction of the army's Camp Fannin was completed, soldiers were a common sight in Tyler during the early days of World War II. Tyler Commercial College provided radio-operation training as a Signal Corps school to over 2,000 army staff between April 4, 1942, and July 31, 1943. The above view shows a class in session. Since no barracks were yet available, the soldiers were housed at the Blackstone Hotel, Bluebonnet Courts Motel, and Alamo Courts Motel. The view below shows soldiers marching across the courthouse square, returning to the Blackstone Hotel after a day of training. (Both courtesy of the Smith County Historical Society.)

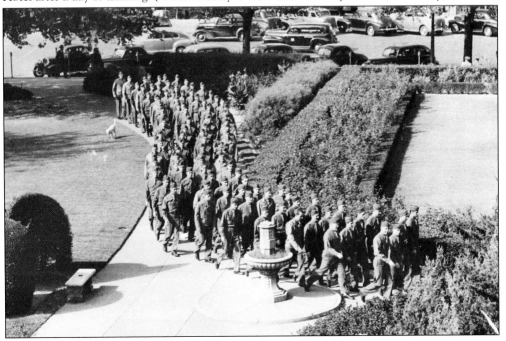

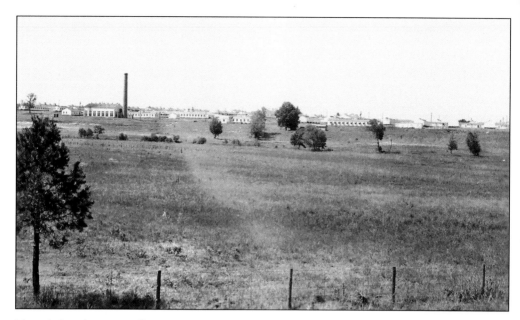

Plans for a military installation about seven miles northwest of Tyler started in mid-1942. Initially it was to be an air corps training center, but soon it became a Branch Immaterial Replacement Training Center for support troops. The final purpose was changed once again to a full-scale Infantry Replacement Training Center to replace Camp Robinson, Arkansas. Covering 15,000 acres, the official name was Camp Fannin, named after Col. James Walker Fannin, a hero in Texas history. Almost 3,000 civilians worked on the camp construction, which had an estimated total cost of $5 million. The first troops were training in August 1943, and the camp trained as many as 35,000 to 40,000 men every four months. The above view is of just a small section of the camp. The view below shows the warehouse area. (Both courtesy of the Smith County Historical Society.)

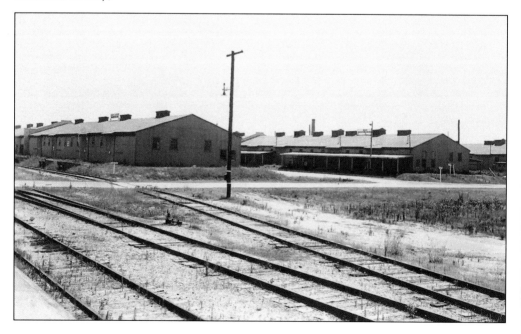

On November 11, 1943, soldiers from Camp Fannin marched in the Armistice Day Parade through downtown, admired by crowds lining the streets. The photograph at right, taken from atop the Peoples National Bank, shows the troops turning east off North College Avenue onto West Erwin Street. With up to 40,000 soldiers housed there at any given time, the camp was a small town. It had a modern hospital, a library, a movie theater, a newspaper, and even its own football team, shown below. A WAC detachment was placed at the camp in 1944 but only remained for six months. After the war, the camp was turned into a separation center for returning troops. The facility was deactivated on June 15, 1946, and returned to the Corps of Engineers, which later disposed of the property. (Both courtesy of the Camp Fannin Association.)

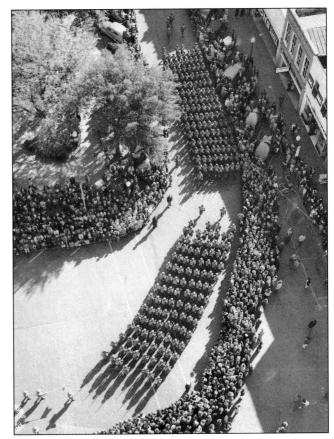

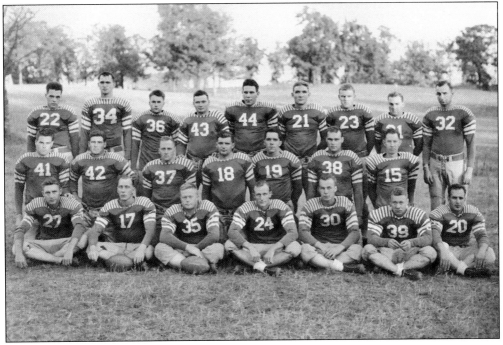

Joint ventures between Camp Fannin soldiers and Tyler civilians included successful camp musical productions. Written by Sgt. Bruce Collier and Pvt. Dick Morris, *Texas Yanks* was a widely acclaimed hit, performed by actors from the camp and local civilian actresses. Morris later produced such Broadway and Hollywood hits as *The Unsinkable Molly Brown*. There were many celebrities, such as Tommy Dorsey and Red Skelton, who entertained the Camp Fannin troops. Dorothy Lamour is shown in the photograph below during a visit. (Left, author's collection; below, courtesy of the Smith County Historical Society.)

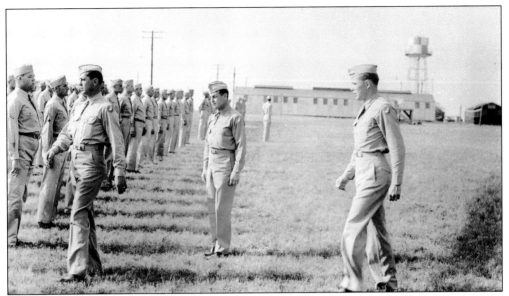

Rhodes Field was leased from the city for use as an army airfield during World War II. The view shows an inspection at the field on May 13, 1944. The first officer from Tyler to lose his life during the war was 2nd Lt. Jack W. Pounds, killed in a 1942 plane crash while serving as a flight instructor in California. The airport was renamed Pounds Field in his honor. (Author's collection.)

From October 1943 to May 1946, German prisoners of war were held at Camp Fannin Internment Camp. Isolated in the northeast portion of Camp Fannin and surrounded by barbed wire and towers with .30-caliber machine guns, 50 barracks, each housing 20 men, were built along with support buildings. Prisoners performed various jobs around camp, such as working in the camp laundry. (Courtesy of the Camp Fannin Association.)

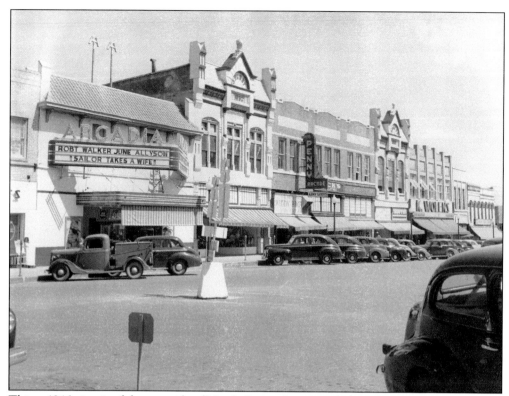

This c. 1946 view is of the east side of North Spring Street, including the Arcadia Theater. On the site of the Arcadia were two earlier movie theaters: the Theatorium from 1907 to 1913 and the Queen from 1913 to 1925. The Arcadia opened in a new building on October 15, 1925. The first "talking movies" in Tyler were shown there on February 13, 1929. (Courtesy of the Smith County Historical Society.)

Bob Wohletz, a former army chef at Camp Fannin, continued to practice his culinary skills after the end of World War II by opening Bob's West Bow Drive-In, shown here around 1946. Located at 623 West Bow Street, both inside and curb service was available, with hamburgers costing 15¢. (Courtesy of Fannie Bell Wohletz.)

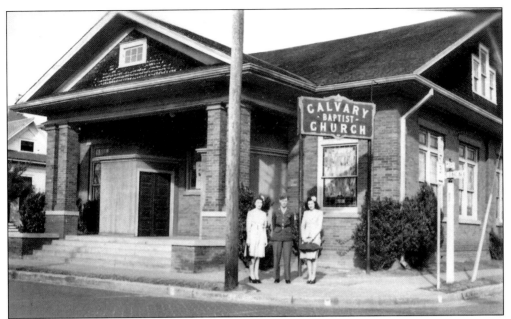

North Baptist Church was organized in June 1890 as a mission of First Baptist Church. Over the next five years, the name changed to Second Baptist Church, then North Tyler Baptist Church. In 1912, the congregation almost disbanded and reunited with First Baptist Church, but prayers kept them going. Their final name change to Calvary Baptist Church occurred in 1930. The above view shows the church in the 1940s, when located on the northeast corner of North Bois D'Arc Avenue and West Bow Street. Their next location on the southwest corner of North Broadway Avenue and West Bow Street is shown in the view below. The first service here was held on June 2, 1946. The church moved again in 1998 to 6704 Old Jacksonville Road. (Both courtesy of the Smith County Historical Society.)

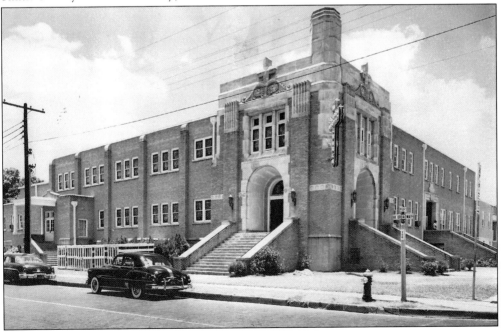

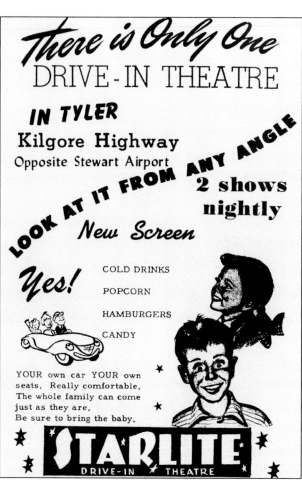

Tyler's first drive-in theatre was the Starlite, which opened in September 1947, located on East Erwin Street just inside East Loop 323. The grand opening was delayed five days due to damage to the grounds from a bad rainstorm. Within a month, the 50-foot-tall screen was toppled by another storm. The drive-in did survive, but it closed in early 1973. On March 30, 1973, it reopened as the Circle but only lasted a few months. Other drive-ins included the Crest, opened March 1949 at 2201 West Bow Street; the Rose Garden, opened January 1951 at 2502 East Fifth Street; and the Apache, opened March 1957 at its original location on Highway 31 West. The advertisement is from 1947. The below photograph is of the miniature golf course located at the rear of Rose Garden Drive-In. (Both courtesy of the Smith County Historical Society.)

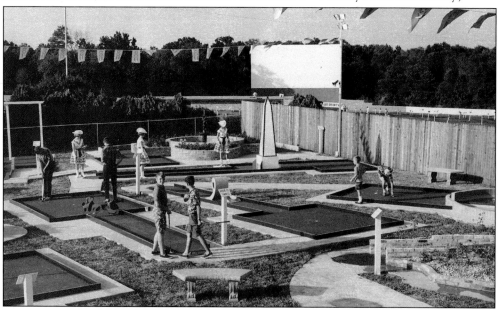

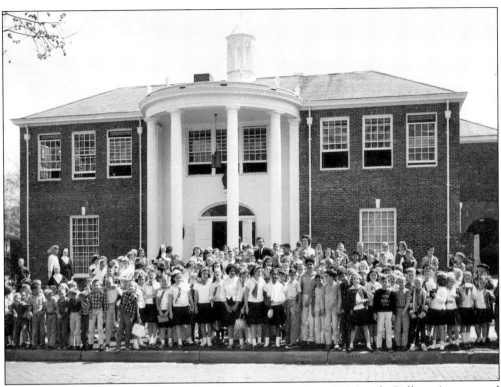

A Catholic parochial elementary school was constructed at 500 South College Avenue and dedicated on January 20, 1946. The land was donated by the Glasco family, and the school was named St. Gregory in memory of their nine-year-old son, Gregory, who died of polio shortly before construction began. The school opened with 102 students, five teaching nuns, and three priests. (Courtesy of the Smith County Historical Society.)

The year 1947 marked the resumption of the Texas Rose Festival after the end of World War II. The theme was "Court of Famous Beauties," and Fiesta Night, a Bergfeld Park show honoring rose growers, was added. The parade float shown is carrying Rose Queen Carolyn Riviere at the top. The 1949 Rose Parade moved from downtown to beginning on West Front Street and ending at the recently completed Rose Stadium. (Courtesy of the Smith County Historical Society.)

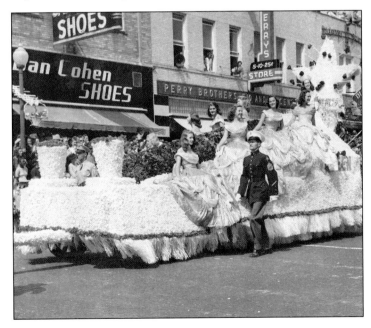

This c. 1940s photograph is of Todd's Barber Shop, also known as Arcadia Barber Shop, which was located at 316 North Spring Street. These gentlemen are, from left to right, Shorty Duncan, Walter L. Todd, ? Brewer, and Kay Elliott. Shorty gave shoe shines, while the other three men were barbers, with Walter being the owner. (Courtesy of Marie Dusek.)

Tyler Junior College opened on September 15, 1926, as part of the public school system and shared the high school campus. In 1946, it separated from the public school system, and a new campus opened in fall 1948 comprised of moved surplus buildings from Camp Fannin, the army training facility that closed after World War II. The main building, shown here, was completed in 1949. (Courtesy of the Smith County Historical Society.)

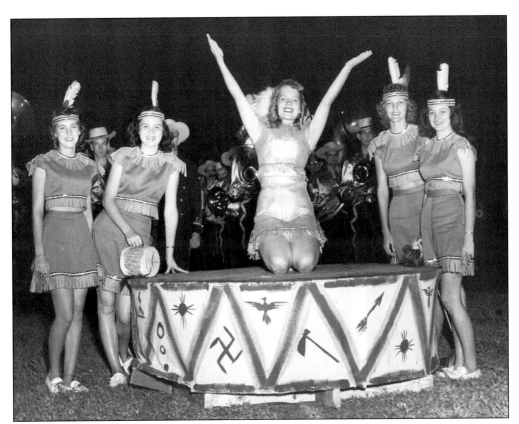

After Tyler Junior College separated from the public school system, a band and girls drill team were created in 1947. The band was organized by "Doc" Witt, formerly director at Tyler High School, and the Apache Belles were organized by Mildred Stringer. Shown in this late 1940s photograph wearing their original uniforms are the Apache Belles, with the Apache Band in the background. (Courtesy of the Smith County Historical Society.)

Al Gilliam was a Tyler High School head cheerleader and directed Camp Fannin's USO shows during World War II. He became dance director of Tyler Junior College's Apache Belles in 1948, a position he held until retirement. He was the first resident director of the Tyler Civic Theatre and director of the Rose Festival Coronation, positions he continued until his death in 1988. (Courtesy of the Tyler Civic Theatre Center.)

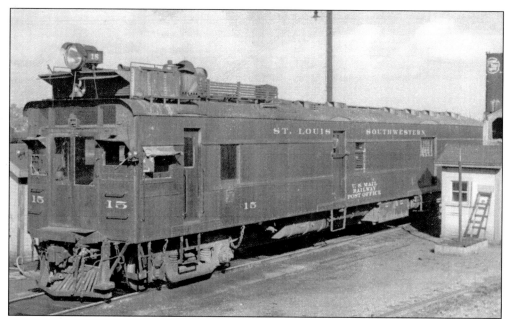

This jitney is shown in the Tyler rail yards in 1948. This Cotton Belt single-car, combination vehicle initially made two round trips daily between Tyler and Lufkin, but later only one. The front third of it contained the power unit, the middle contained a post office, and the back was a passenger area. The jitney made its last run in November 1949. (Courtesy of the Smith County Historical Society.)

Shown is the Tyler Junior College team that won the 1949 National Junior College Basketball Championship. From left to right are (kneeling) pilot F. W. Strine, coach Floyd Wagstaff, Wilson Richardson, Buddy Matthews, David Rodriguez, manager Jimmy Doggett, and Ted Hunt; (standing) Jerry Champion, Jack Revill, Ramon Orona, Herb Richardson, Jose Palafox, Bryan Miller, Kenneth Pemberton, Sid Holliday, *Tyler Courier-Times* sports editor Jim Dean, and Brady Gentry. (Courtesy of the Smith County Historical Society.)

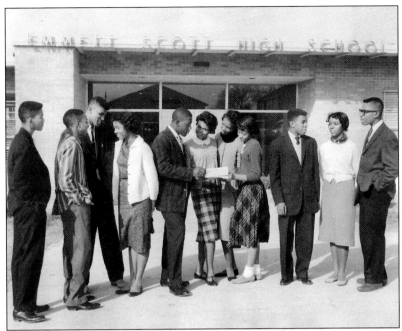

In the early days, segregation was the norm. Initially there was the West End Colored School, built in 1888 on Herndon Street, and the East End Colored School, later called Dunbar, was built in 1894. In 1921, a three-story building was erected at 1230 North Border Avenue for all black students, with the elementary grades leaving when Peete and Austin Elementary Schools were built. The building was soon named Emmett J. Scott Junior-Senior High School. In 1949, Emmett J. Scott High School was completed at 1901 North Englewood Avenue, followed over the next eight years by numerous additions. It was one of three Tyler schools closed in 1970 to comply with desegregation court orders. Both views are of Emmett J. Scott, the above from 1959 and below c. 1963. (Both courtesy of the Smith County Historical Society.)

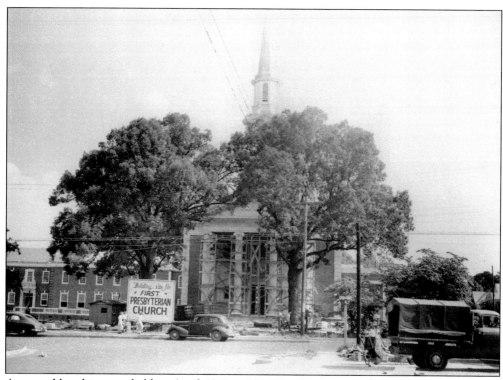

A ground-breaking was held in April 1949 at 230 West Rusk Street for construction of a new First Presbyterian church. The construction is seen in this 1949 photograph. The congregation moved to their home in 1950. (Courtesy of the Smith County Historical Society.)

Jimmie's Café was located at 1605 West Erwin Street. Owner James W. Prickett (middle) stands in front of the business in this October 1950 photograph. The restaurant offered drive-in service, including Italian, Mexican, barbecue, and chicken-based foods. (Courtesy of the Smith County Historical Society.)

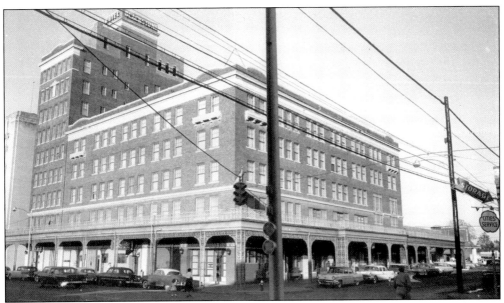

The Blackstone Hotel underwent a $1 million renovation and enlargement in the 1950s. An east wing of 30 rooms and a parking garage were added. A cast-iron portico around the sides gave the hotel a New Orleans flavor. Facing North Broadway Avenue were several businesses, including the Creole Coffee Shop, radio station KTBB, and the Tyler Chamber of Commerce. The hotel's exterior after these changes is shown above. The June 1964 view below is of the restaurant located in the Gregorian Room. By 1956, Joe Zeppa of the Delta Drilling Company was the sole owner of the Blackstone. As business slowed over the years, only Joe's philanthropy kept the doors opened. He died in July 1975, and the hotel closed on December 31, 1975. It was imploded in October 1985. (Both courtesy of the Smith County Historical Society.)

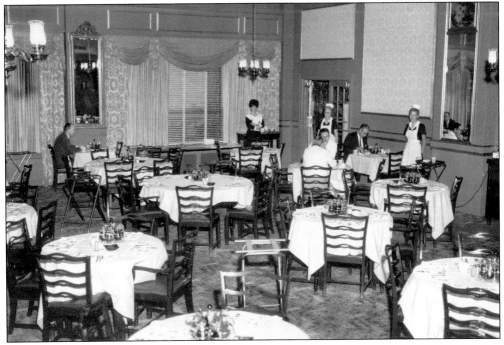

Stewart Blood Bank, shown at its original location at 817 Clinic Drive between Mother Frances Hospital and Medical Center Hospital, opened on June 21, 1951. Walter Stewart provided the funds for construction and equipment, while the East Texas Hospital Foundation provided the land. A building expansion was approved by the board in 1956 and was completed. (Courtesy of the Smith County Historical Society.)

Texas Eastern School of Nursing started in 1951 as a joint project of Tyler Junior College and the Tyler hospitals. East Texas Hospital Foundation constructed the pictured school and dorm building in 1958 at 801 Clinic Drive. In 1982, the school moved to, and became solely operated by, Tyler Junior College when it changed to an associate-degree nursing program. The building became the Pavilion, used by East Texas Medical Center. (Courtesy of the Smith County Historical Society.)

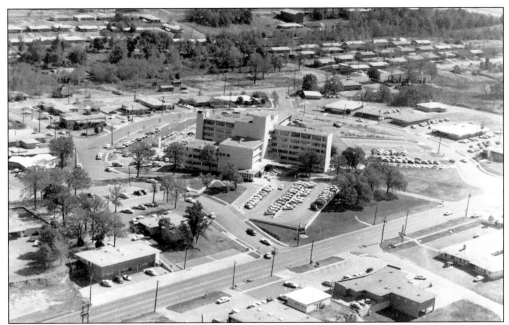

The largest project of the East Texas Hospital Foundation was to build Medical Center Hospital, which was made possible with a bond issue approved by Smith County residents and a federal grant. Opened in September 1951 and located at 1000 South Beckham Street, the original five-story structure, shown above, included nurse quarters and employed 200 workers. In 1961, it founded the first eye bank in East Texas. Bond elections in 1965 and 1968 made possible a building project that tripled the hospital's size. The most visible parts of this expansion in the view below are the radial nursing units, a hospital-design concept with the nursing station in the center of a group of rooms. In 1968, an ambulance program headquartered at the hospital was pioneered with four ambulances responding to 200 calls each month. (Both courtesy of the Smith County Historical Society.)

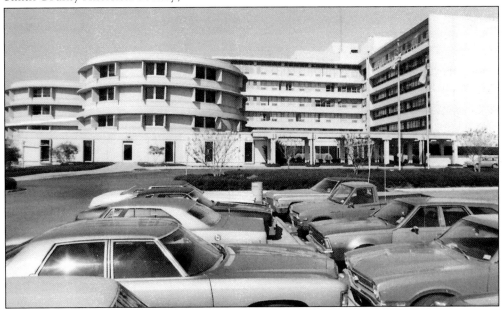

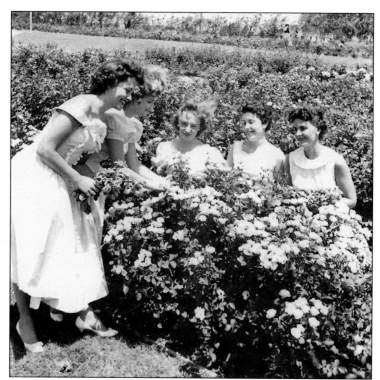

Improvements were made on an eroded area on the east side of the East Texas Fairgrounds, and with the help of Dr. Eldon Lyle and $5,000 appropriated by the city, landscaping and soil improvement began. It all culminated in a municipal rose garden dedicated in June 1952. Tyler-area growers donated the rose bushes, with 3,000 planted the first year. Vandal Alford, Miss Tyler of 1951, planted the first bush. The results are shown in the 1957 view above. In 1953, the Rose Garden Center, shown below, was built as an entrance overlooking the gardens and included a greenhouse wing. Walkways, lampposts, and fountains were added, as were thousands of more roses over the years, and the gardens became recognized as the largest municipal rose garden in the United States. (Both courtesy of the Smith County Historical Society.)

In 1952, St. Louis Southwestern Railway president Harold J. McKenzie presented Alice Douglas a pin commemorating the 75th anniversary of the railroad. Alice was the widow of James P. Douglas, the founder of the Tyler Tap Railroad in 1877, which was the oldest section of the St. Louis Southwestern Railway, better known as the Cotton Belt Railroad. (Courtesy of the Smith County Historical Society.)

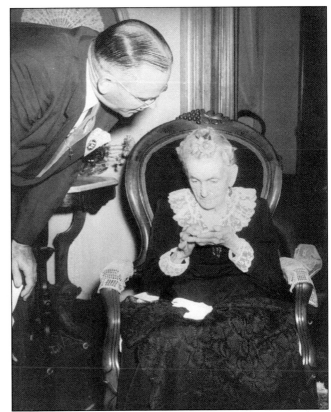

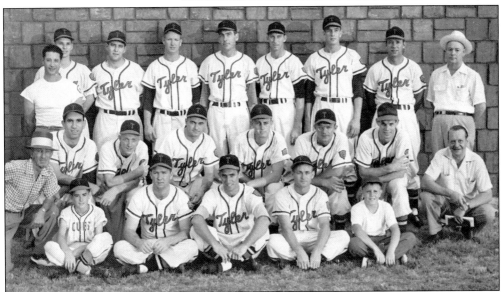

Shown is the Tyler East Texans 1952 baseball team, the last to win a minor-league championship for the city. Tyler has had its share of minor-league baseball teams over the years: the Elbertas, 1912; the Trojans, 1924–1931; the Sports, 1932; the Governors, 1933–1934; the Trojans again, 1935–1940, 1946–1950; the East Texans, 1951–1953; the Tigers, 1954–1955; the Wildcatters, 1994–1997; and the Roughnecks, 2001. (Courtesy of the Smith County Historical Society.)

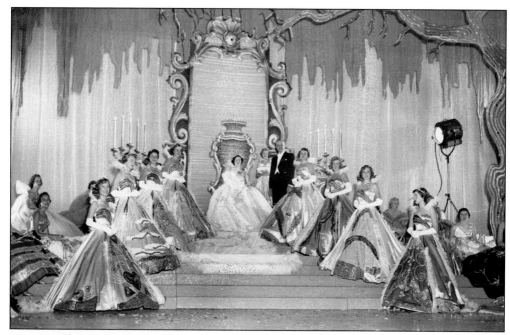

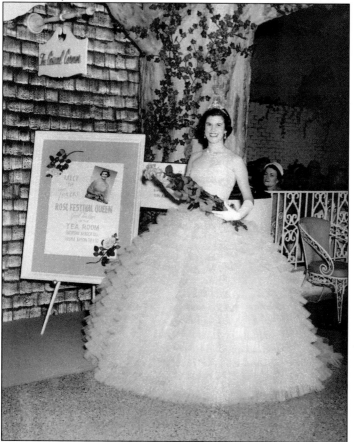

Shown above is Rose Queen Sally Kay's coronation in 1953. The festival's theme that year was "Festival of Fantasy." Aspects of the Rose Festival continued to change over the years. In 1956, the queen's tea was moved from the home of the queen's parents to a large lawn in the municipal rose garden. Shown at left is 1956 Rose Queen Gail Hudson, making an appearance at a tearoom. The theme for the festival that year was "The Splendor of Light." (Both courtesy of the Smith County Historical Society.)

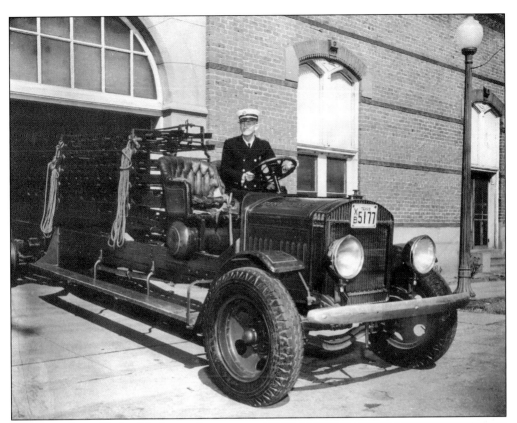

This view shows Harlan Hodges at the Locust Street Fire Station on Ladder No. 4. The truck was in service from 1917 to 1954, and for many years after being retired was relegated for children to play on in Goodman Park. (Courtesy of the Smith County Historical Society.)

Located on the northeast corner of South Broadway Avenue and East Elm Street, the 16-story Carlton Hotel opened in November 1954 with 200 guest rooms, meeting halls, and a coffee shop. The opening ceremony featured actress Gloria DeHaven and bandleader Joe Reichman. The hotel closed on November 18, 1971, stood vacant for years, and was purchased for Smith County use in 1977. (Courtesy of the Smith County Historical Society.)

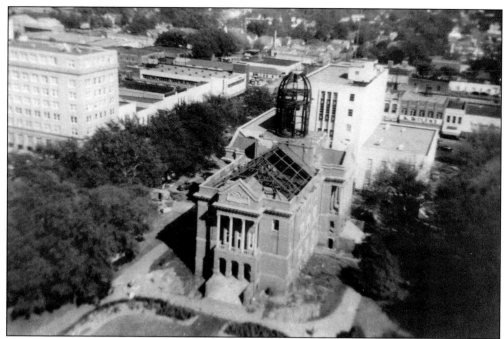

In a move still regretted by many Smith County residents, construction of a new county courthouse immediately east of the existing one was started on February 23, 1954. Dedication of the new $1.5 million structure was on August 1, 1955, with demolition of the old building starting about two months later. The above photograph shows the first stages of that demolition, while the view below shows the new courthouse standing alone after Broadway Avenue was extended through the original courthouse square. Remnants of the former courthouse's landscaping are still visible in the foreground. (Both courtesy of the Smith County Historical Society.)

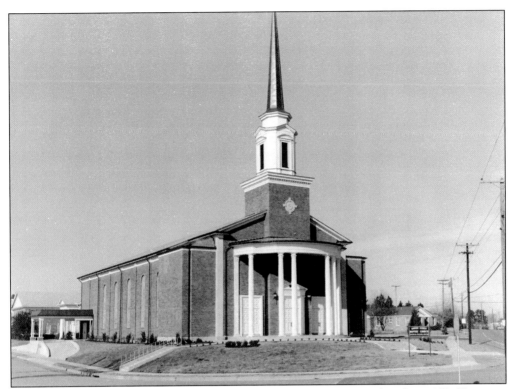

W. V. Henson, a deacon of First Baptist Church, decided to start a new church in 1952. Two acres were soon purchased for a mission church. The first service, officiated by Rev. Cecil Johnson, was held on January 26, 1955, in the new Green Acres Baptist Church located at 1607 Troup Highway. In 1968, the chapel and fellowship hall were damaged by fire, but the church rebuilt and has been expanding ever since. (Courtesy of the Smith County Historical Society.)

Harold J. McKenzie lived in Tyler and was president of the St. Louis Southwestern Railway, better known as the Cotton Belt Railroad, from 1951 to 1969. Harold was responsible for moving the Cotton Belt general offices to Tyler. The building, located at 1517 West Front Street, was dedicated on March 22, 1955. The county purchased the building in 1985 to alleviate courthouse overcrowding. (Courtesy of the Smith County Historical Society.)

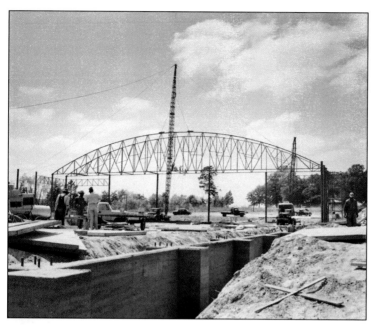

Bobby Manziel Sr. began construction on the Oil Palace in 1955. Located at 10408 Highway 64 East, this 20,000-seat coliseum was to be a sports venue managed by his friend Jack Dempsey, the former world heavyweight boxing champion. However, Bobby died in 1956, and the complex sat uncompleted for years. His son, Bobby Jr., finished the building in 1983. (Courtesy of the Smith County Historical Society.)

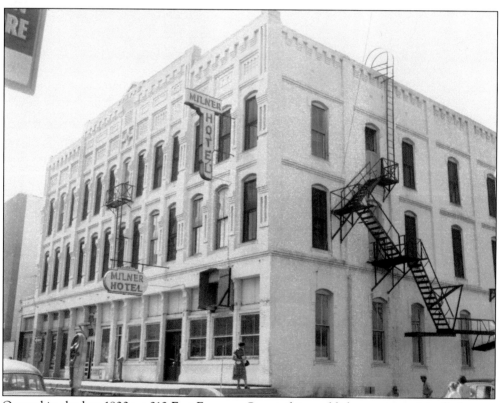

Opened in the late 1800s at 212 East Ferguson Street, this establishment was originally known as the National Hotel. The name changed to Hotel Tyler in the mid-1910s and to Milner Hotel in the early 1950s. The photograph was taken in 1955, only a year or two before the hotel closed and was demolished. (Courtesy of the Smith County Historical Society.)

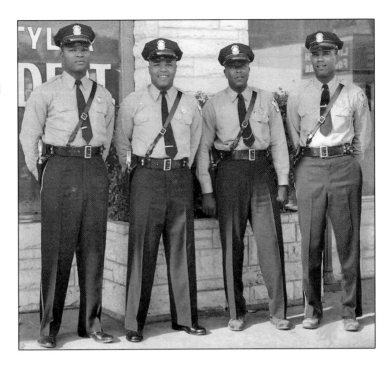

This December 1955 view shows, from left to right, W. Houston, Alvin Anderson, Willie Johnson Sr., and Ira Brown. Willie and Ira were the first black officers in the Tyler Police Department, hired in 1954. (Courtesy of the Tyler Police Department.)

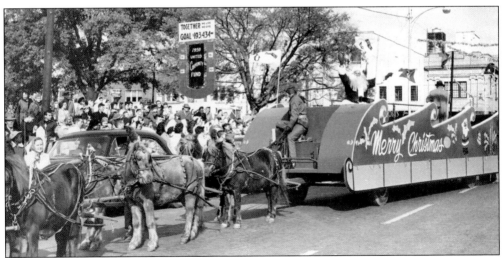

Shown is the annual Christmas Parade passing through downtown on December 7, 1958. Santa's sleigh is minus his usual reindeer. Many Tyler citizens have fond memories of the parade, followed by the first lighting of the Christmas tree on the square. For many years, Santa had a small house on the square, where children could share their wish lists with him. (Courtesy of the Smith County Historical Society.)

Santa Claus Rocket Corporation, a Tyler company managed by Lloyd B. Laster, had a fleet of these custom-built vehicles. Santa, along with a space hostess, pilot, and copilot, visited children and gave rides and candy. There were at least three different designs, each approximately 40 feet long, 12 feet high, and 8 feet wide. Each vehicle's own power plant allowed flashing Christmas lights and music. (Courtesy of the Smith County Historical Society.)

Billie Sol Estes was tried in Tyler on embezzlement charges in 1962, and the trial was one of the first televised. Many claimed that the media presence turned the whole affair into a "circus." In 1965, the U.S. Supreme Court overturned the sentence, saying that the "televising and broadcasting of the proceedings" denied due process. (Courtesy of the Smith County Historical Society.)

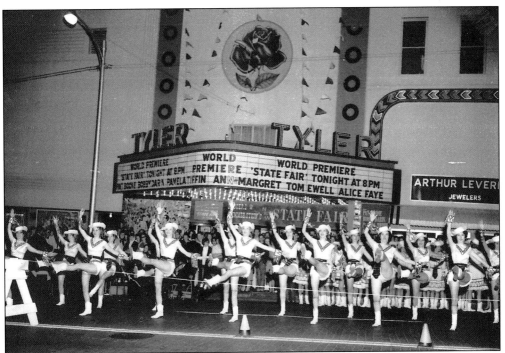

After opening on August 2, 1940, the Tyler Theater drew crowds to its downtown location of 111 South Broadway Avenue. When the 1962 world premiere of the motion picture *State Fair* occurred simultaneously in 11 Texas cities, the theater was one of the locations. The above view shows the Tyler Junior College Apache Belles performing in front of the theater during the premiere festivities. Also in conjunction with the film's release, actress Ann Margret paid a visit, shown below being welcomed with roses by Apache Belles after her arrival at Tyler Pounds Field. From left to right are Sara Turner, Glenda Carter, Ann Margret, Camille Carter, and Dee Hernandez. The Tyler Theater continued to entertain audiences until its closing on September 16, 1982. (Both courtesy of the Smith County Historical Society.)

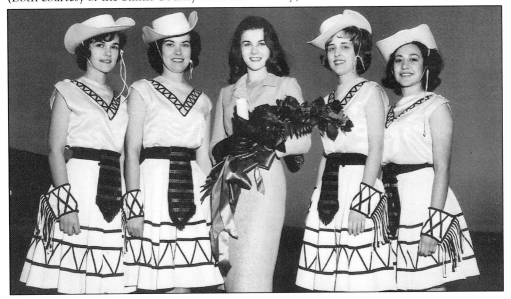

On the morning of September 12, 1963, a break in Tyler State Park's earthen dam drained the entire lake down Saline Creek into the Sabine River, flooding pastureland along the way. No injuries were reported, and the dam was rebuilt. The above photograph shows the diving platform in the swimming area in front of the bathhouse, while the photograph below shows the boathouse, surrounded by stranded paddle and flat-bottom boats. The people on the docks to the left are looking down at the "water train," which carried passengers in a series of boats on tours of the lake. (Both courtesy of the Smith County Historical Society.)

The chamber of commerce organized the first Azalea and Spring Flower Trail in 1960. Originally there was only one trail that was 5 miles long. The tradition of Azalea Belles stationed along the route started in 1964, made up of the secretary staff of the chamber. Later they became students from Tyler high schools. Over the years, the trails expanded and additional events were added. (Courtesy of the Smith County Historical Society.)

This view is looking north up South Broadway Avenue around 1960. Standing out are Peoples National Bank and Carlton Hotel. A closer look down the right side of Broadway Avenue beyond the Carlton Hotel will reveal, in order, the 1955 county courthouse, Citizens First National Bank, and Blackstone Hotel. Just beyond Peoples National Bank is Mayer and Schmidt, while Tyler Commercial College is on the nearer side. (Courtesy of the Smith County Historical Society.)

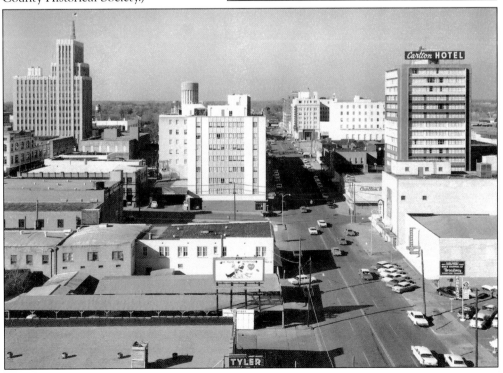

Discover Thousands of Local History Books
Featuring Millions of Vintage Images

Arcadia Publishing, the leading local history publisher in the United States, is committed to making history accessible and meaningful through publishing books that celebrate and preserve the heritage of America's people and places.

Find more books like this at
www.arcadiapublishing.com

Search for your hometown history, your old stomping grounds, and even your favorite sports team.

Consistent with our mission to preserve history on a local level, this book was printed in South Carolina on American-made paper and manufactured entirely in the United States. Products carrying the accredited Forest Stewardship Council (FSC) label are printed on 100 percent FSC-certified paper.